Goya: The Third of May 1808

Art in Context

Edited by John Fleming and Hugh Honour

Each volume in this series discusses a famous painting or sculpture as both image and idea in its context – whether stylistic, technical, literary, psychological, religious, social or political. In what circumstances was it conceived and created? What did the artist hope to achieve? What means did he employ, subconscious or conscious? Did he succeed? Or how far did he succeed? His preparatory drawings and sketches often allow us some insight into the creative process and other artists' renderings of the same or similar themes help us to understand his problems and ambitions. Technique and his handling of the medium are fascinating to watch close up. And the work's impact on contemporaries and its later influence on other artists can illuminate its meaning for us today.

By focusing on these outstanding paintings and sculptures our understanding of the artist and the world in which he lived is sharpened. But since all great works of art are unique and every one presents individual problems of understanding and appreciation, the authors of these volumes emphasize whichever aspects seem most relevant. And many great masterpieces, too often and too easily accepted and dismissed because they have become familiar, are shown to contain further and deeper layers of meaning for us.

Art in Context

*Francisco José Goya y Lucientes was born at Fuendetodos, near Saragossa, Aragon, on
30 March 1746 and died at Bordeaux on 16 April 1828. His father was a gilder.
He was trained in Saragossa under José Luzán and possibly Francisco Bayeu whose sister
he married. He went to Italy and was in Rome in 1771, returning to Saragossa
that year. In 1773 he settled in Madrid, working for the royal tapestry factory and
eventually established himself as a fashionable portrait painter. He was appointed
painter to the King, 1786, Court Painter, 1789 and First Court Painter, 1799. A serious
illness left him permanently deaf in 1793. He painted frescoes in San Antonio de
la Florida, 1798, and announced the publication of the* Caprichos *in 1799. During the
French occupation he swore allegiance to Joseph Bonaparte and received the
Napoleonic 'Royal Order of Spain', but was reinstated as Court Painter at the Restoration
in 1814. He published* La Tauromaquia *prints in 1816 and began to execute his
Black Paintings in the* Quinta del Sordo *in 1820. He settled in Bordeaux in 1824,
returning to Madrid briefly in 1826 when he resigned as First Court Painter.*

*The Third of May 1808 is painted in oil on canvas (266 x 345 cm.). With its companion
piece,* The Second of May 1808, *it was commissioned by Cardinal Don Luis
María de Borbón, President of the Regency Council, who, in response to a petition of 24
February 1814, awarded Goya 1,500 reales on 9 March 1814 to 'perpetuate with
his brush the most notable and heroic actions or events of our glorious insurrection against
the tyrant of Europe'. It is not known when they were publicly exhibited. Both are
recorded in the store of the Prado in 1834 and were put on permanent display shortly
afterwards. They were removed from Madrid in 1936 during the Civil War and
sent to Valencia, Barcelona and finally Geneva, suffering some damage in transit. In 1939
they were returned to the Prado in Madrid.*

Allen Lane The Penguin Press

Goya: The Third of May 1808

Hugh Thomas

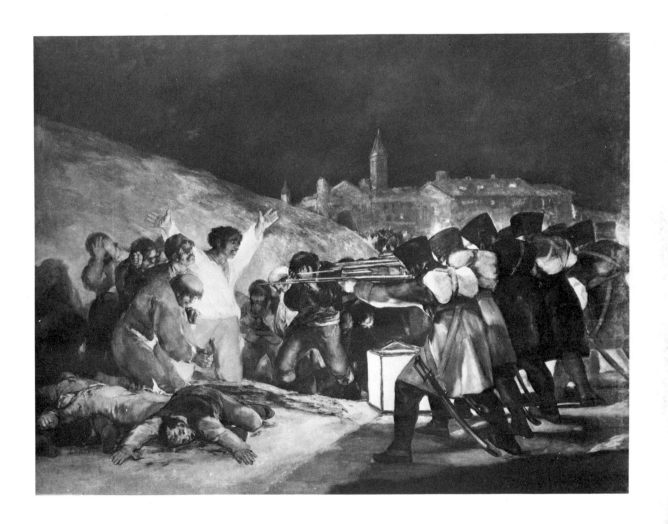

Copyright © Hugh Thomas, 1972
First published in 1972
Allen Lane The Penguin Press, 74 Grosvenor Street, London W1
ISBN 0 7139 0301 5
Filmset in Monophoto Ehrhardt by Oliver Burridge Filmsetting Ltd, Crawley, England
Colour plate printed photogravure by D. H. Greaves Ltd, Scarborough, England
Printed and bound by W. & J. Mackay & Co. Ltd, Chatham, England

Designed by Gerald Cinamon

Acknowledgements

My thanks are due to several people who have kindly given me advice during the writing of this book. These include: Mrs Juliet Wilson, Señora Elena Páez, Mr Benedict Nicolson, M. François Lachenal, Señor Xavier de Salas and Mrs Enriqueta Frankfort. The latter read the text in draft and made many valuable suggestions. My thanks are also due to the staff of the Warburg Institute and the library of the Victoria and Albert Museum.

Hugh Thomas
March 1972

Historical Table

1808 April: Murat occupies Madrid. 2 May: Spanish rising begins. 6 May: Charles IV forced to abdicate. 6 June: Joseph Bonaparte King of Spain. 1 August: flees from Madrid after Battle of Bailén. 13 December: Madrid capitulates to Napoleon.

1809 16 January: Sir John Moore killed at Corunna. Winter 1808–9: Siege of Saragossa. 28 July: Wellesley victorious at Talavera, created Duke of Wellington. French overrun Andalusia, except for Cádiz.

1810 Spanish colonies in America refuse to acknowledge Joseph Bonaparte. Wellington holds Torres Vedras.

1811 8 May: Wellington defeats French at Fuentes d'Onoro. Venezuelan independence under Simón Bolívar; Paraguay and Argentina declare independence.

1812 19 January: Wellington takes Ciudad Rodrigo. 19 March: Cortes of Cádiz passes liberal constitution under hereditary monarch. April: British capture Badajoz. June: Napoleon invades Russia. July: Wellington takes Salamanca and, in August, takes Madrid. October: retreat from Moscow begins.

1813 21 June: Wellington routs French at Vittoria; Joseph Bonaparte flees Spain. 11 December: Napoleon agrees to restore Ferdinand VII of Spain.

1814 30 March: allies enter Paris. April: Napoleon banished to Elba. May: Ferdinand annuls the constitution; Pius VII returns to Rome, restores the Inquisition and revives the Index and Jesuits. November: Congress of Vienna.

Goya, *Equestrian portrait of Ferdinand VII*. Gros, *Battle of Eylau*.	Goethe, *Faust* part I. Beethoven, Fifth Symphony.	1808
Goya, *The Colossus*.	Chateaubriand, *Les Martyrs*.	1809
Goya, *Allegory of the Town of Madrid*; begins *Disasters of War*. Gros, *Capture of Madrid*. David, *Distribution of the Eagles*.	M. de Staël, *De l'Allemagne*.	1810
Goya is awarded the Royal Order of Spain by Joseph Bonaparte.	Goethe, *Dichtung und Wahrheit*.	1811
Goya, *Equestrian portrait of the Duke of Wellington*. Gros, *Equestrian portrait of Murat*. Géricault, *Officier des Chasseurs*.	Hegel, *Logic*. Byron, *Childe Harold*.	1812
Goya: *The Third of May 1808* and *Portrait of Ferdinand VII*.	Chateaubriand, *Bonaparte et les Bourbons*. Scott, *Waverley*. Beethoven, *Fidelio*, in final two-act form.	1814

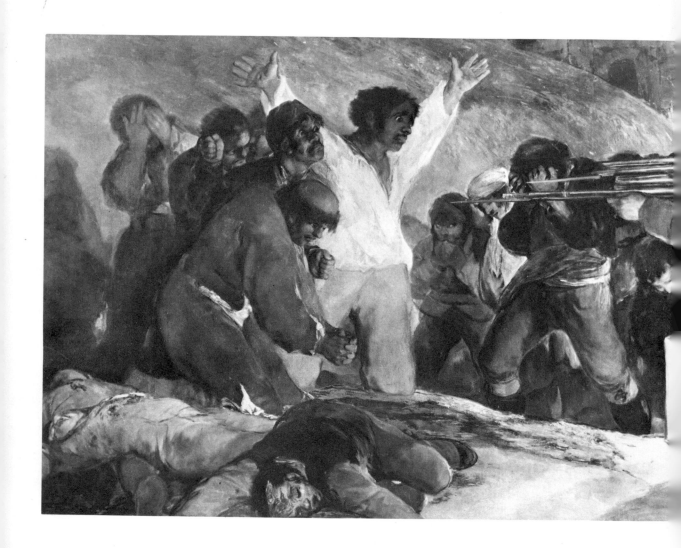

1. *The Third of May 1808* (detail)

1. The Third of May 1808:
The Shootings on the Hill of Príncipe Pío

It is a brutal picture. The man in the white shirt is about to be shot. No last minute order countermanding the execution can save him, for the order to fire has evidently been given. This is the moment before the explosion.

But it is not only the central figure who is to die. The light from the soldiers' square lantern is on him – and man and lantern, both white and yellow, are balanced – but the four or five men beside him will also be shot. One of these men, on the right of the central figure, seems to be a Franciscan father. Farther on, in the centre of the picture, there are more men, of whom four evidently will soon follow to the execution mound; and behind them, in a ragged file, stretching to beneath the church or the monastic buildings in the background of the painting, other victims shuffle forward [1].

It must be night, but presumably it is almost dawn, for the sky is beginning slightly to lighten and anyway that is the customary hour for executions in civilized countries, such as this one must be, to judge from the character of the architecture in the background. The light from the lantern is not great, hence the executioners are at point blank range; unless perhaps the artist has foreshortened the distance between the riflemen and the victims in order to heighten the horror of the scene. To prove the irrationality of their task, has the painter also made these eight soldiers jointly take aim in front of them, even although the farthest to the right could not possibly reach the target?[1]

Among the doomed men, eyes and hands are specially suggestive. The man in the white shirt, with his curious looks (half gipsy, even half Negro, unless his looks are meant to seem distorted because of

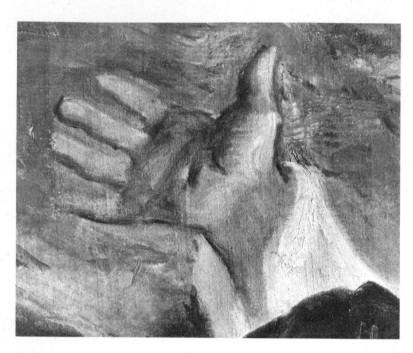

2, 3. *The Third of May 1808* (details)

terror) has his arms outstretched, in resignation or defiance, or perhaps in answer to an order; anyway, it seems as if we are before a kind of lay crucifixion. His right hand appears to be pierced in the palm [2] and perhaps swollen to make this interesting comparison with a crucifixion even more close.[2] His eyes, wild though they look, stare rather emptily down the barrel of the rifle of the executioner [3]. On his right, the friar stares at the ground, his hands clasped, presumably in prayer, though it is possible that they are bound. Another victim has both hands clenched, but his right hand is in the air, his left hand by his side. This man's eyes are fixed on the night sky, avoiding the executioners with his glance, already glimpsing, perhaps, a sight of the next world about whose existence he surely, from his expression, has no doubts [4]. One man behind has covered his face; another, a man of sensitivity from his looks, perhaps an intellectual, is calmly looking past those in front of him at the soldiers, almost in spite of himself. His head is bent and possibly even now he could hope to escape, or escape with a wound,

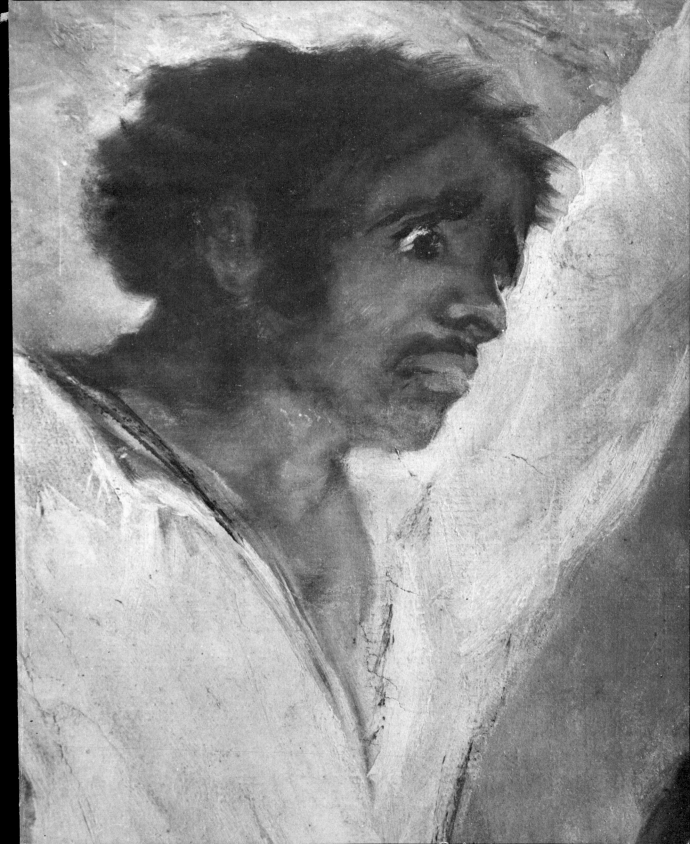

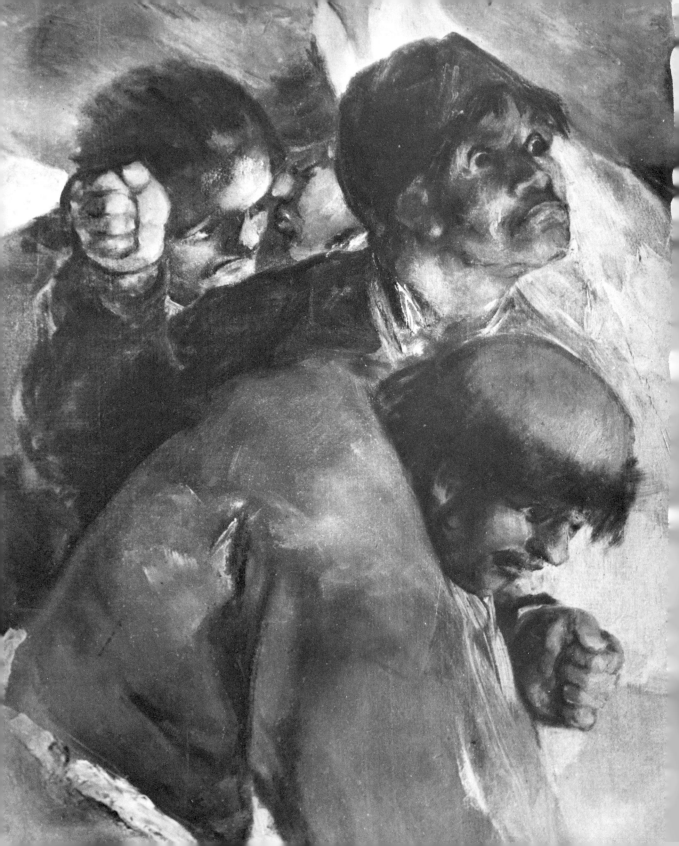

were it not that the executioners clearly intend, with this batch of prisoners, as with the last, to bayonet the dead or the dying, after shooting them.

All these men about to die seem to be on their knees. Are they perhaps meant to seem, in their realistic coarseness, all saints or apostles, so often depicted in this fashion by, at least, Spanish painters? None of them seems specially brave: all seem human.

There is one more pair of eyes which catches the attention: that on the right of the file of men walking up to be shot. His hands are over his mouth; perhaps a moment ago, they, like those of the big

4, 5. *The Third of May 1808* (details)

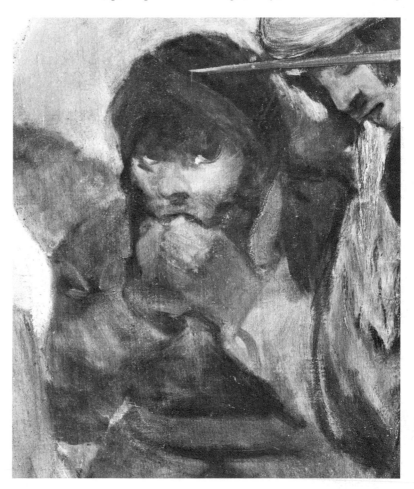

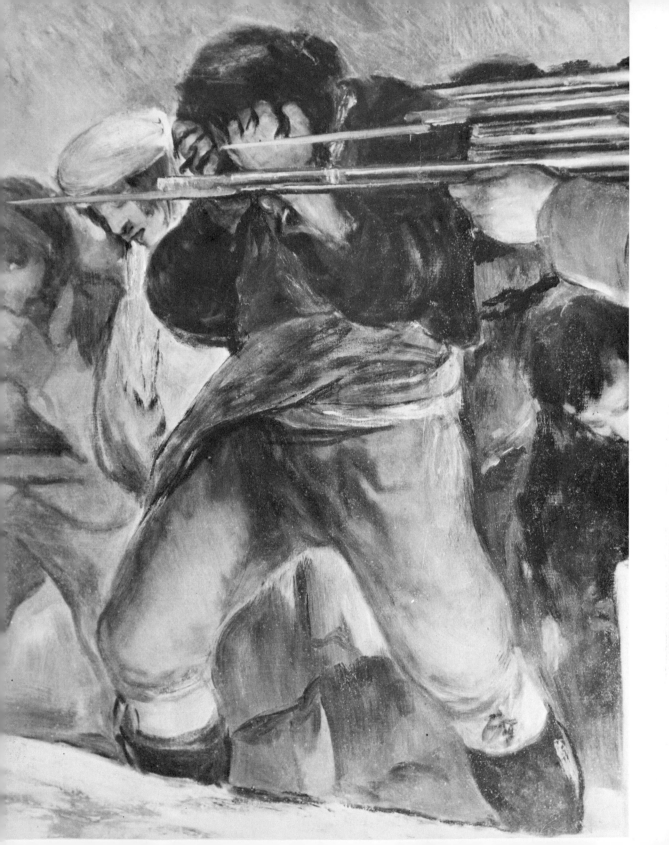

man on his left, in red breeches and boots, were over his eyes to hide the scene. But he has permitted himself, looking upwards, to take in what is going on. The eyes are slanted. They show fear and awe. The whites of these eyes suggest a child, or a horse [5].

In the centre of the picture a man in white stoops with closed eyelids. He has apparently over his head a white hat or a linen sheet used as a bandage. The end of the first bayonet lies across one eyelid and doubtless this placing is not accidental, since it symbolizes, in microcosm, one theme of the picture: the end of vision. Another bayonet happens to lie across the hands of the man in the red breeches and red sash [6].

Finally, there are the closed eyes and outstretched hands of the blood-encrusted man who is dead in the foreground of the picture. The head and eyelids are covered with blood, though not the hands, which are outstretched, like those of the central figure [7]. Indeed,

6, 7. *The Third of May 1808* (details)

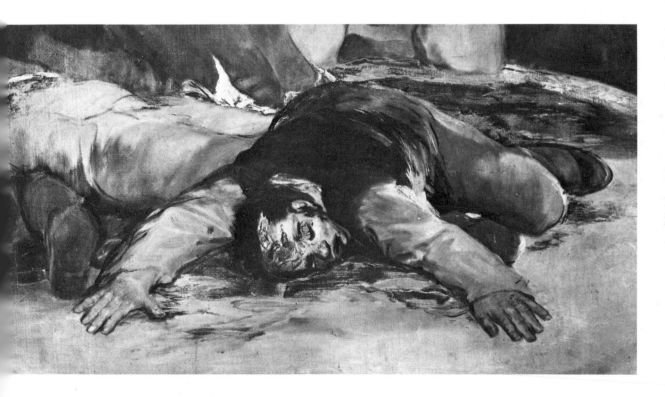

the position of the dead man is such that he must, a few minutes before, have been in the same kneeling position as the central figure, who will himself, in a second, reel over and hit the ground in almost the same spot. Moreover, the file of men coming up from the right will also presumably be in the deadly centre of the picture within a short time. The position of the three groups of figures is suggestive of a reel of film, showing not only an execution but also the moments before and after the action, showing what the spectator might see at three successive but separate moments. Beyond, on the left of the picture, lies the bloody body of another victim, scarcely distinguishable, more a carcass than a human being.

The executioners, unlike their victims, have no eyes visible. The heads of these long-coated soldiers are bent low over their weapons, as if in shame or as if part of a relentless machine. Only one hand, that of the foremost soldier, is visible of the many which make up the picket. Instead of hands, there are guns, and legs, positioned doubtless in the correct drill stance for an execution squad, well apart to resist the recoil of the rifles. The executioners present a more or less straight line, while their victims are huddled and disorganized, a confused mass at bay before the precision of modern weapons [8].

One other figure catches the attention. It is that on the far left of the painting. At first sight it seems that that must be a shadow cast by the men about to be killed. But, on second thoughts, some doubts arise: perhaps indeed, as the Swedish art historian, Folke Nordstrom, has suggested in his study of Goya,[3] it may be a shadowy representation of the Virgin Mary, or even the Virgin and Child, inopportunely standing as a silent witness of damnable events [9].

The mound against which the executions are being carried out is an appropriate background, for, bleak and inhospitable, it is without vegetation. The regularity of the curve along the skyline, the blotchy character of the surface, are reminiscent of latterday photographs of the earth seen from the stratosphere.

On the centre right of the picture there are buildings which, in their implicit sophistication, contrast with the execution. There is

8. *The Third of May 1808* (detail)

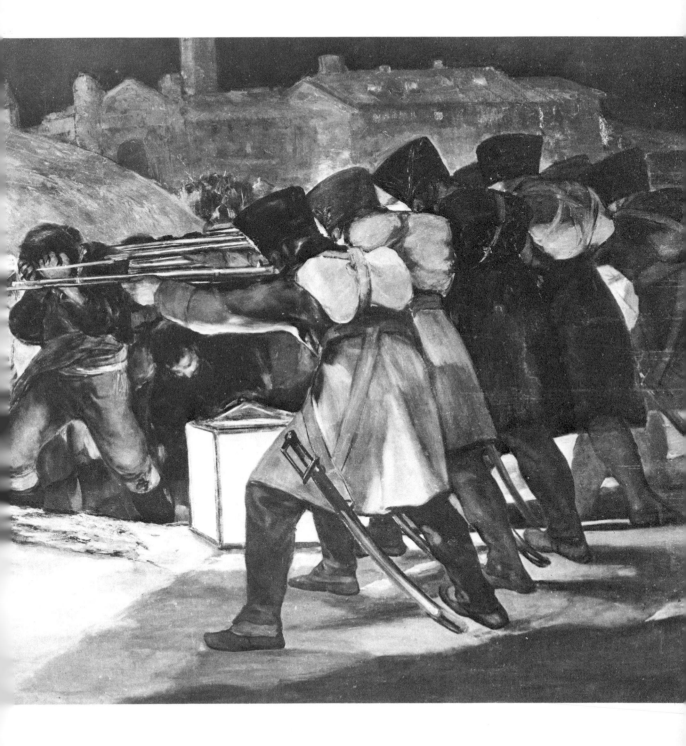

the tower and the spire of what seems to be a seventeenth-century church; before it, an arch leading to what might be a monastery. The looming presence of these gloomy religious buildings remind us that both groups in the picture, the doomed and the killers, are probably Christians; that the omnipotent God worshipped beneath that belfry permits the most surprising outrages; and perhaps, too, that human beings are always at the mercy of heavy and sombre institutions.

If this picture had been found in an attic without any clue being available as to its authorship or provenance, much could be discovered about it from internal evidence. The uniforms of the soldiers tell something, for it was only during the Napoleonic wars that trousers, as worn by the execution picket, replaced gaitered breeches. The shako, too, which is worn by these men with, apparently, a waterproof cover, came in at that time, as did the sabre with the square handle, suitable for cutting rather than for thrusting. Such clues might enable an expert to decide at a glance that these soldiers, with packs on their backs, were French infantrymen of a line regiment, though perhaps he would be a little puzzled that the first soldier seems to have an officer's sword; and he might hesitate at the appearance of what seems to be an oak leaf on the second soldier's shako, unless perhaps, it is the imprint of an eagle through the waterproof cover. Another expert still might comment that the picture must be in some details, at least, imaginary, since nineteenth-century executions, such as these, were rarely carried out by uniformed men. The different colours of the soldiers' coats are also a little disturbing until it is observed that these must be winter overcoats of undyed wool; and, incidentally, that first soldier with the officer's sword has slung his weapon far too low and therefore quite incorrectly by any standard known to military discipline. Possibly the unusually large lantern, presumably almost two feet high, with glass sides, might betray its origin, though from its size it seems to be of the sort which normally hung outside shops or in streets. (The light is not quite convincing; why does it reflect so much towards

the right of the painting, or is there another concealed source of light somewhere on the right?) An historian of lanterns might help a little perhaps, and tell whether the light comes from candles or from oil; he would point out that this lantern has, apparently, no vent for fumes; and perhaps, who knows, some architectural historian might recognize the buildings in the background as being part of Madrid.

For this is a real historical scene. The condemned men are probably Spanish patriots who had fought against the French occupying army the day before, on 2 May 1808, a famous day in Spanish history – patriots only *probably*, since, along with real fighters against the French, some quite innocent people were also shot. The site of the executions is real too: it is the Montaña del Príncipe Pío, or 'mountain' of Prince Pius, in the city of Madrid, so called after Prince Pío of Savoy, an Italian soldier of fortune who became captain-general of Madrid and died in 1723. He married the heiress of a Spanish family, the marquises of Castell Rodrigo, and so inherited a large estate between the city of Madrid and the River Manzanares. In old prints, the casa del Príncipe Pío can be clearly seen – a long, low and undistinguished building sheltered by the Montaña. This estate occupied most of the land between what is today the Calle del Marqués de Urquijo in the north, the Manzanares in the west, the Calle Princesa in the east and the Plaza de España in the south. This large area has included, since the mid-nineteenth century, the station and marshalling yards of the Estación del Norte and the public gardens of the Florida area. The actual hill where the executions occurred was probably below the site of the Montaña barracks, a scene of fighting during the Civil War of 1936-9. These barracks were afterwards destroyed and, after being left a ruin for a long time, this place has now been made into a park.[4]

The soldiers in the picture are not easily identifiable, but they were probably French infantrymen of the rather second-rate calibre that Napoleon, who despised Spain at that stage, dispatched south of the Pyrenees in early 1808. They may have been men from the

'legion of reserve' used earlier to do garrison duty on the Atlantic coast. Or they may have been men of one of the twenty 'provisional regiments' that the Emperor sent to make up 30,000 of the army of Spain. It is just possible that they were members of the Imperial Guard whom the French general Murat had with him but the odds are against it, save that Murat's own headquarters was at that time near this spot. It is also conceivable that, like many of the soldiers of the French revolutionary army, they were from detachments of Italians, Poles, Swiss, Germans or other auxiliaries.

The buildings in the background of the picture are difficult to identify. From a consideration of the site of the executions, they could be either a distant view of old Madrid or the group of buildings around the church of San Francisco. But the latter church has a great dome, one of the largest in the world, as Goya well knew, since in the early 1780s he had spent a longer time than at any other period of his life on a single picture beneath it, depicting St Bernardino of Siena preaching. The simple towers do not resemble very clearly either those around the Plaza Mayor or the Town Hall, nor those of the other churches still in existence which lie between the Royal Palace and San Francisco, such as San Andrés, nor indeed any towers that there are now in Madrid. The tower of San Nicolás, in the Plaza S. Martín, bears some resemblance but it seems scarcely credible that that building, far away in the centre of the city, could be the one depicted. Is it then the case that the whole group of buildings was simply invented, as an effective backcloth of *conventos* and grim palaces? It is certainly possible, but, if so, why did Goya pay such special attention to these particular corners and details of construction? Perhaps again, as Folke Nordstrom has suggested, thus carrying the crucifixion *motif* even further, the artist has meant to suggest that we are on Golgotha, and that the walls are those of Jerusalem. But Goya often gave a lowering if sometimes indistinct line of buildings as a background to his compositions [10, 43].

Contemporary prints and other sources suggest that the towers and walls might very well represent an impression, at least, of an

10 *(left). Dream of Lies and Inconstancy*
(detail), *c.* 1799. Goya

11 *(right). View of Madrid*
(detail), *c.* 1790. Lecerf

12 *(far right). La Pradera de San Isidro*
(detail), *c.* 1788. Goya

actual line of buildings, those, that is, lying between the Montaña del Príncipe Pío and the royal palace, from an angle which included and includes many unexpectedly prominent towers of churches or convents: it is possible that Goya checked these things for himself on the spot in 1814. See, for example, the detail of the 1790 aquatint by Lecerf [11]: here such towers are plainly to be seen. Something similar to the general background of the picture can also be seen on the left of one of Goya's own earlier paintings, namely *La Pradera de San Isidro* [12]. As to what happened to the buildings themselves, it seems certain that, if they were the churches or the *conventos* that they appear to be, they must have suffered or even been burned down in one of Spain's many civil wars, perhaps only in 1936, perhaps as early as 1835, when so many monasteries were abandoned.

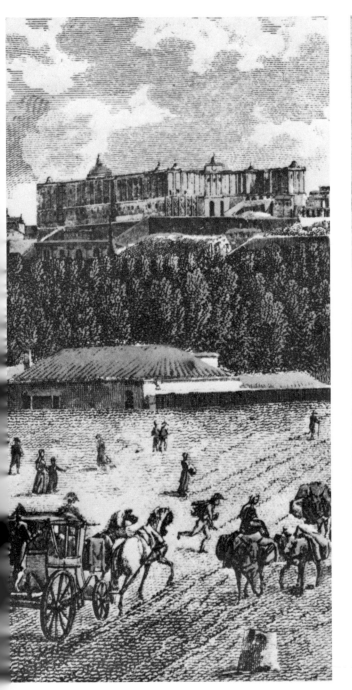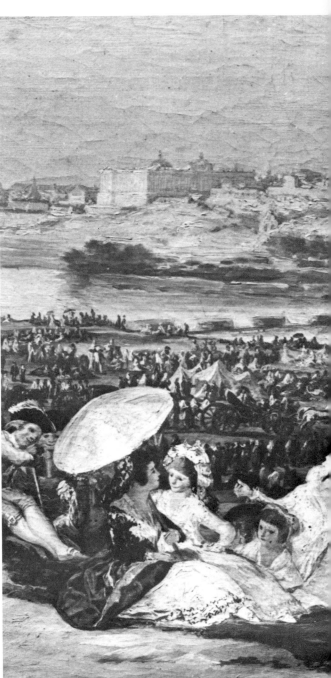

Although Goya was in Madrid at the time of the events he depicts in this picture, it was not painted until 1814 when, on Goya's own suggestion, it was commissioned by a new Spanish government pleased to commemorate in grandiose style a dramatic event which had occurred at the beginning of what turned out to be a long 'war of independence' – the Spanish name for what the English still call the Peninsular War – against the French.[5] The painting, along with its companion entitled *The Second of May 1808* [13] depicting the

13. *The Second of May 1808*, 1814. Goya

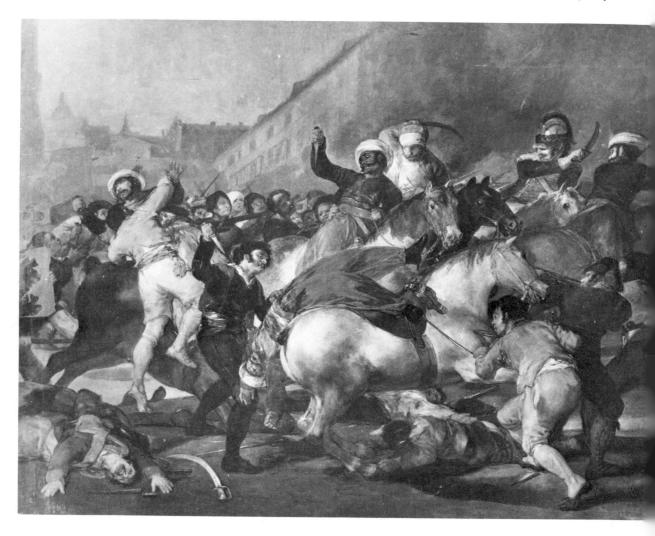

rising in the Puerta del Sol, was thus a piece of official art, however unusual in style, though carried out by a painter who had, for the six years which intervened between the events depicted and the painting itself, brooded upon and illustrated in etchings and some less ambitious paintings, the nature of war and violence. It is believed that Goya was interested in painting other commemorative pictures of this sort and it was even once suggested, without evidence, that he completed two more pictures in the series (representing a riot in front of the royal palace and a revolt at the Montera barracks). Both paintings, which today hang side by side in the Prado (separated by an undated self-portrait of Goya of about 1815) illustrate events which have become symbolic of the birth, or re-birth, of Spanish nationalism, and of the fatal ambiguities which attended this delivery.

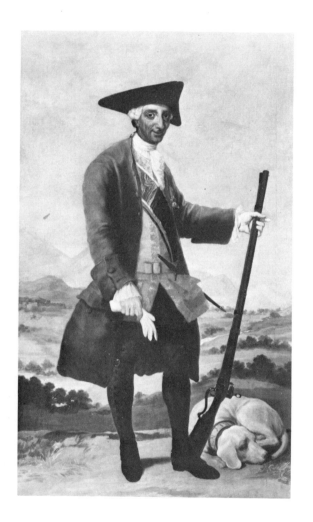

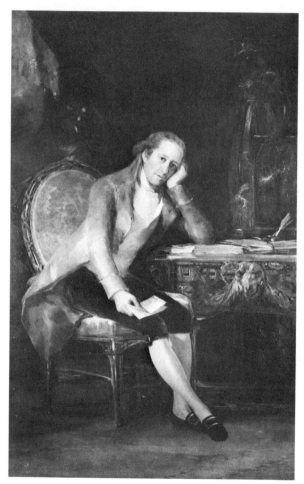

14. *Charles III in Hunting Dress*,
1786–8. Goya

15. *Don G. M. de Jovellanos*,
1798. Goya

2. The May Risings

The dramatic events of May 1808 were decisive for the subsequent history of Spain, and to some extent of Europe, not to speak of South America. For the riots in Madrid on 2 May and the shootings of 3 May were the beginning of the Spanish popular revolution against the French and that itself was almost as great a contributory cause of the final defeat of Napoleon as the retreat from Moscow. Napoleon soon sent some of his best troops to Spain where they were tied down for four years; had they been available to reinforce the often second-rate armies with which he had to fight in central Europe and Russia, the history of the world might have been different. Yet, as Goya knew, the tragedy of those days was that they spelled the end of popular backing in Spain for the French as the radical reformers that they continued to be regarded in Italy and in Germany. These events divided Spaniards between those enlightened patriots who still believed that the French could regenerate Spain, and those traditional ones – the vast majority, including the 'friars and the masses' of popular legend – who were inspired to resist. The consequent war of independence was the first of those civil wars in Spain which have so damaged the country, causing 'liberalism' to be easily identified by its enemies with the enemies of the nation. If Goya, who, while the French remained in Madrid sometimes collaborated with them, and who completed *The Second of May* and *The Third of May* along with other pictures partly perhaps to work his way back into royal favour, had painted the faces of the execution picket, perhaps he could not have resisted the suggestion that they were the soldiers of Reason.

During the eighteenth century, the Spanish administration, both in Spain and in the still enormous Spanish Empire in the Americas,

had set on foot a series of reforms in government inspired by the precedents of France and provoked by a stealthy diffusion of French economic and political literature. These reforms were aimed primarily at improving the efficacy of administration, to limit anomalies of justice deriving from regional differences, and to reduce the power of religious orders and of the Church. Although it seems increasingly that the beginning of this Spanish revival must be attributed to the beginning of the century, even to the end of the seventeenth century, the men particularly associated with these new departures in Spanish life are King Charles III (1716–88: King of Spain from 1759 till his death [14]) and his ministers Campomanes (died 1802), Floridablanca (died 1808) and Jovellanos (died 1811) [15], all of whom were men of quite humble origin. That these enlightened ideas were not simply the idiosyncrasies of a few politicians is suggested by the growth of the voluntary Societies of Friends of the People which, beginning in the Basque country, extended their activities, in particular by establishing libraries, learned periodicals and lecture courses throughout the whole empire. It is also evident that the indigenous Spanish curiosity of men such as the monk Feijóo (himself influenced by Francis Bacon more than by any Frenchman) played a considerable part in inspiring the beginnings of this movement. Much was done; a new concordat gave the monarch power over the Church for the first time, local idiosyncrasies of all regions except Navarre and the Basque provinces were mostly abolished, and the educationally and culturally dominant Society of Jesus was expelled. Agriculture and industry were stimulated by government action (for example, foreign cloth was finally banned to help Barcelona in 1771 and guild restrictions were reduced) and so was trade with the New World – this last by the removal of most of the many restrictions on free commerce even within the Empire which had persisted since the sixteenth century. Roads began to be built radiating from Madrid. Speaking in general terms, Spain in the last quarter of the eighteenth century was both more prosperous and more intellectually alive

than at any previous time. But these reforms were an attempted revolution from above and unfortunately 'the propaganda of *luces* [that is, enlightenment] could [not] quickly create in Spain a bourgeoisie in the French image'[6] – at least not outside Barcelona and Bilbao. In the Empire, the reforms, by rendering the government of Madrid and its local representatives more efficient, aroused resentment. That in its turn helped to create the climate of opinion which led to the wars of independence in the first quarter of the nineteenth century. The activities of Charles III and his ministers were enough to wet the appetite of the Spanish Empire for reform but could not satisfy anyone. In Spain itself, then a country of some ten million inhabitants, aristocratic, clerical and popular antagonism was aroused (as indeed in other countries ruled by 'enlightened despots'); the reduction of local rights of course increased the influence of the state and so heightened the importance of quality among the actual rulers; the poverty, the deeply rooted local patriotisms, the superstitions and the intellectual backwardness of the country, could not be changed overnight; and the Inquisition was still able to restrict to a minimum the import of French and other foreign books and even to punish, on occasion, anyone who read them. There had been some ruinous trials by the Inquisition even during the reign of Charles III – the case of the Intendant Olavide sentenced for heresy in 1778 being the most sensational; none of the most devoted friends of the Enlightenment were ever able to break with orthodox religion as such, and the fragility of the method by which the modest reforms were being undertaken was shown by the events following the death of King Charles III in 1788.

The new King, Charles IV, aged forty when he came to the throne, was powerfully influenced by his lively and strong-minded wife, María Luisa of Parma (his first cousin), and she by the upstart royal favourite, Manuel de Godoy, who was made prime minister in 1792. This 'Trinity on earth', as the Queen put it, was penetratingly depicted by Goya [16, 17, 18]. Godoy's appointment

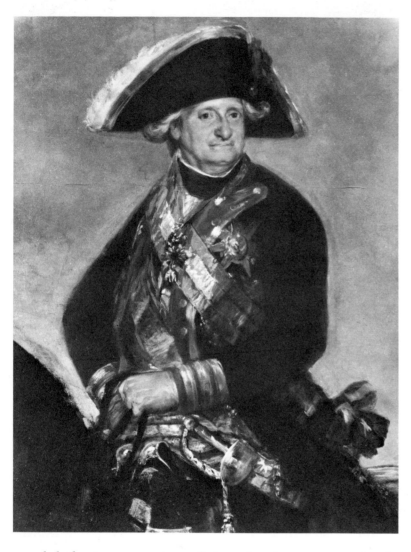

16. *Charles IV on Horseback*
(detail), 1799. Goya

17 *(right)*. *María Luisa on Horseback*
(detail), 1799. Goya

revealed the tenuous nature of the reforming apparatus in the Spanish government. For under his rather complacent and personal administration, Spain was rendered specially weak just when the French Revolution and its international consequences brought Spain, like every other country, many difficulties. Nevertheless, with King Charles IV lazy and preoccupied by hunting, and with Queen María Luisa increasingly enthusiastic, Godoy remained

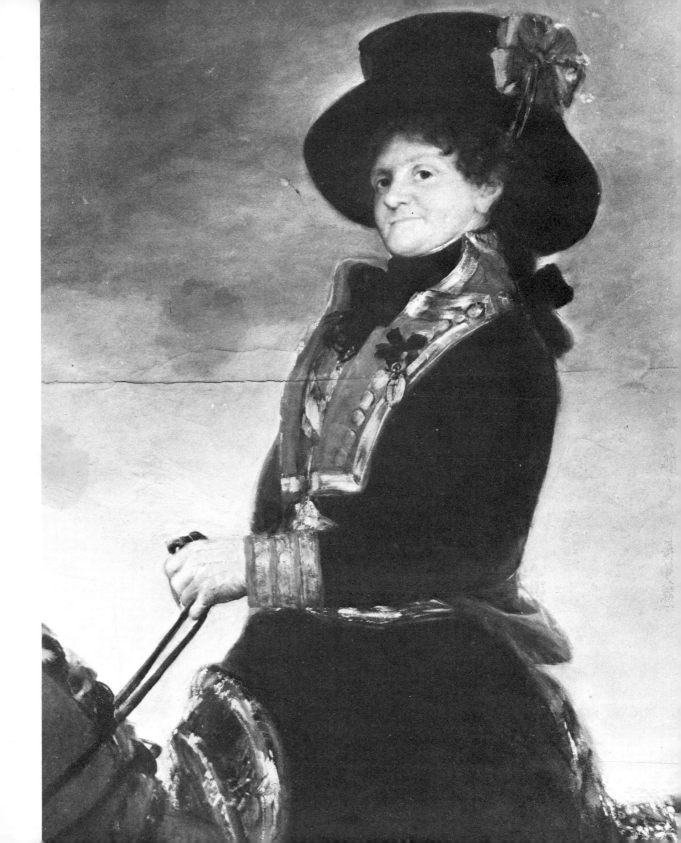

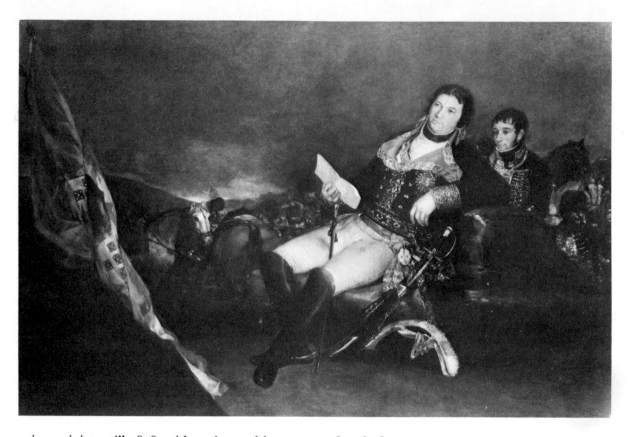

18. *Don Manuel de Godoy*, 1801. Goya

prime minister till 1808, with an interval between 1798 and 1800, when the *ilustrados (éclairés)* were briefly in power. Almost any alternative Spanish government would have found itself in treacherous waters when dealing with Napoleon and the French revolutionary governments. Had Godoy flourished twenty years earlier, he might easily have matured with power, and died beloved and honoured. As it was, and since the consequences were so dire, the triangle of the King, Queen and Godoy became one of the most famous in history. Godoy was believed to be the Queen's lover, though about this there is some doubt. He was in the end apparently as much attached to the King as to the Queen, while all three were perpetually exchanging rather trivial inquiries about each other's health. Godoy maintained his own mistress and, in the

end, married the King's niece. He was much disliked by the aristocracy, though his capture of power seems appropriate in an age when the noblemen and the noblewomen of Spain were fond of dressing up as members of the lower orders and pretending to be street-dandies (*majos* and *majas*), the cult of *majismo* being the Spanish equivalent of the French obsession with shepherds and shepherdesses. Godoy also disliked bullfights and indeed temporarily abolished them, while appreciating Goya, whom he patronized – a somewhat peculiar transposition, since Goya was a great admirer of bullfighting. Lady Holland, a good judge of human beings, visiting Spain in the early 1800s, found the King 'quite a *bon homme*' and the Queen 'uncommonly gracious', showing 'great readiness in making conversation and taste in choosing topics'. On the whole, this 'trinity' seems to have been unfairly treated by historians; and Spain was probably a happier place in their time than during most of the nineteenth century.

The first reaction of the Spanish government – then still directed by Floridablanca – to the French Revolution had been to attempt to keep out all possible contagion by closing the frontiers, breaking off diplomatic relations and imposing a strict security check on the quite large French colony then living in Spain itself. Godoy took part in conservative Europe's first crusade, in 1793, against atheism and regicide, and personally profited much from the signature of peace in 1795: having already been made Duke of Alcudia, he was now made Prince of Peace, the only non-royal Spanish prince, in honour of the ending of the war. But there could be no stopping the arrival of 'French ideas' and Spain seemed in many ways in the mid-1790s an intellectual cauldron. Godoy, attracted by the thought of using French power against the old enemy, England, also drew Spain into an alliance with France. War with England lasted sporadically till the peace of Amiens in 1802; it was renewed in 1805, but that venture resulted in the defeat at Trafalgar, when the Spanish fleet was destroyed. This gave England control of the Atlantic for ten years and cut off Spain from her colonies, who were

thereupon obliged to act with self-reliance to which they became thereafter all too accustomed.

By this time Godoy's apparent misconduct of affairs had made him most unpopular, though, apart from the loss of the fleet and casualties in Spanish armies fighting in Flanders and elsewhere, he had only lost the Empire the island of Trinidad while, in compensation, he had won back Menorca from the English: a by no means unsatisfactory exchange. The continuous success of the French army, meantime, impressed others besides himself. One undoubtedly sound cause for complaint against Godoy, however, was that he allowed the Spanish army to run down very badly. At all events, in late 1806, after the impressive French victories at Austerlitz and Jena, he concluded with Napoleon the unwise Treaty of Fontainebleau. By this, Spain agreed to help Napoleon in the conquest of Portugal, by now England's last ally on the continent. Portugal was to be divided, the northern section to go to the King's grandson Carlos, the son of the Infante Luis, who, as part of an earlier scheme between Napoleon and Charles IV, had been briefly king of a short-lived kingdom of 'Etruria', an Italian territory cut out of Tuscany; while the south would go as a principality to Godoy himself. Godoy perhaps thought he saw in Napoleon, like himself a self-made man, a protector for the day, presumably not far off, when King Charles should die. A French army under Junot soon arrived in Spain and with considerable *brio* passed on to capture Lisbon at the end of 1807. The Portuguese royal family then fled to Brazil in a British ship.

Napoleon had, however, apparently never had any intention of fulfilling his side of the bargain concluded at Fontainebleau. Spain under Godoy and the Bourbons seemed an untrustworthy ally, especially after preparations for war made by Godoy in 1805, when Napoleon was busy with the Prussians. Against whom had Godoy been preparing to strike? Later Napoleon claimed other than mere strategic reasons for his action, for in retrospect ideology assumed a greater importance than those military considerations

which had been uppermost in his mind at the time: 'In the battle of new ideas, in the century's case against the old Europe, I could not leave Spain in arrears of the social reorganization; it was absolutely necessary to draw that country along, willingly or by force, in the French movement.' More and more French troops started arriving in Spain, so that even Godoy began to be apprehensive of the Emperor's intentions, particularly when these Frenchmen were cheered *en route*. Fearing for the persons of the King and Queen, Godoy planned to dispatch both to Seville, out of the way, as he hoped, of the French soldiery. But the news of this patriotic plan leaked out and, being misunderstood, became the final spark which set alight the strong antipathies felt for Godoy by wide sections of Spanish opinion.

The consequence was that the son-and-heir of the King, the Prince of Asturias, Ferdinand [19], who had for some time been jealous of his parents' interest in the favourite and had been for several years the centre of the quite large group of disgruntled courtiers and noblemen who hated Godoy, staged a *coup d'état*. This was the so-called Tumult of Aranjuez (17 March 1808), in which the Prince and the aristocrats used their influence to excite an anti-Godoy mob even in the comparative tranquillity of the isolated palace at Aranjuez, about thirty miles south of Madrid. The King's favourite residence had been constructed thirty years before in a green valley renowned for its strawberries, while he was still Prince of Asturias.

This event was not quite without a precedent in the recent history of Spain; the Marquis of Esquilache, the unpopular Neapolitan minister of Charles III, had been hooted out of power by rioters forty years before, in 1766, complaining at rises in food prices. In 1808 it is possible that Prince Ferdinand paid the ringleaders (but then the Church and Jesuits were held to have done so in 1766).

The mob broke into the palace while Godoy hid in a rolled-up mat in an attic. The King and Queen were physically prevented from leaving Aranjuez and the King was persuaded to dismiss

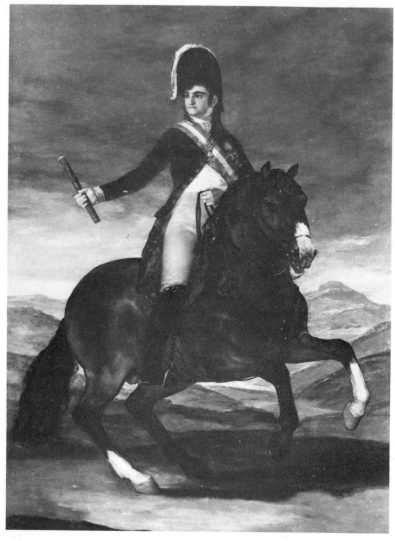

19. *Ferdinand VII*,
1808. Goya

Godoy as prime minister in the hope that he would thereby save the
Prince of Peace's skin. Two days later, the same mob of 'soldiers and
peasants' – who they were we shall doubtless never know – per-
suaded the King to abdicate in favour of the Prince of Asturias, who
now proudly appeared on the scene as the saviour of the country
though he was, in fact, one of the most ignorant, vain, treacherous
and cruel of princes, if not without a certain peasant astuteness. The

King agreed to these humiliations in order to try and save Godoy. Nevertheless the minister was soon found, beaten and only saved from death by the efforts of a royal bodyguard.

But neither the new King nor, needless to say, the Madrid mob was able to remain for long in control of the unprecedented situation. The French revolutionary army, led by Napoleon's dashing brother-in-law, Murat (who himself thought that he might become the radical King of Spain if he played his cards well), was already at Aranda, in Castille. After the news of the Tumult of Aranjuez, Murat moved quickly on to Madrid with 20,000 infantrymen and a large body of cavalry, this being perfectly legal and unobjectionable under the terms of the Treaty of Fontainebleau. As expected, he was welcomed with open arms. Once in Madrid, Murat and his generals showed that they were the masters. Playing, on the one hand, on ex-King Charles's desire to save Godoy, and, on the other, on Ferdinand's hope of currying favour with Napoleon, Murat not only induced Charles temporarily to withdraw his abdication but persuaded both him and Ferdinand to go north to meet Napoleon. At this time, the French were supposed by many to favour Ferdinand and were therefore still enjoying some popularity. Murat's own private hopes were not known. The entire royal family, therefore, set off expecting to meet Napoleon as equals, first Charles and María Luisa, and then Ferdinand. Godoy went with them. They were persuaded, against the advice of the majority of those Spaniards who met them *en route*, to go not only to northern Spain but to France in order to meet the Emperor of the French at the Château of Marrac, near Bayonne. But when they got to the château they were held prisoner. Even Murat, meantime, was kept in ignorance of Napoleon's real plans for Spain.

The apparent agreement of Ferdinand to collaborate with Napoleon cut the ground from under the feet of most of his friends. So, though the fabric of the Spanish state was damaged by the humiliating journey to Bayonne, and though the demands of the French officers in Madrid were vexatious, the City Council, the

Junta del Gobierno (Ferdinand's ministry left behind) and the Council of Castille (the supreme executive, legislative and judicial body) cooperated with Murat. The consequence was that, once again, the Madrid population leapt into the breach, led and egged on by a number of patriotic and anti-French junior officers. As with the rioters of March, the possibility cannot quite be excluded that the mob was inspired or even bribed by either Ferdinand or the Junta de Gobierno. It is also possible that many of the actual rioters were peasants who had come to the market the previous day and, excited by the air of political tension, merely remained overnight. Or were these the same who, in the Tumult of Aranjuez, had already smashed one throne?

The rioters of 2 May 1808 were clearly excited by the news of the imminent abandonment of Madrid by the remaining members of the royal family, such as the Infante Antonio Pascual, the King's brother, and the King's two children, Francisco de Paula Antonio (putatively the son of Godoy), and María Luisa, the 'Queen of Etruria'. The mob in the square outside the royal palace tried to prevent the two last named from leaving the city. A French equerry was unhorsed and was only saved from being lynched by a detachment of Spanish soldiers. Fighting went on, however, and Murat had to send reinforcements, who drove out the mob from the proximity of the royal palace. But the blood of the *madrileños* was up and many French soldiers walking in the streets in their uniforms were set upon and killed. The difficulty for Murat and the Spanish Junta de Gobierno was that most of the regular Spanish army at that time was away in Flanders. So the French army, in large numbers, were moved out from their camps outside the capital and went in to the centre of the city, while what there was of the Spanish army remained in their barracks. There followed much more sporadic fighting, particularly in and around the Puerta del Sol, then, and throughout the nineteenth century, the real heart of the capital. The mob succeeded in taking over the arsenal in the Calle de Montera and in winning the sympathy of two captains of artillery,

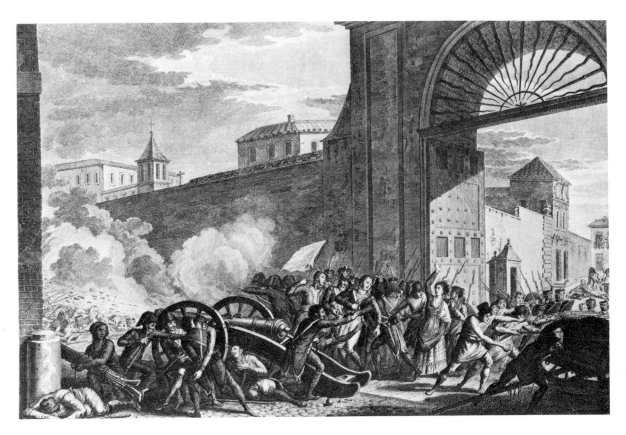

20. *The Second of May 1808 in Madrid.*
Anonymous

Daoiz and Velarde, but, in the end, both this centre of resistance and all others were reduced [20]. By two o'clock in the afternoon Murat had restored order and two Spanish leaders of the Junta del Gobierno, General O'Farril and Miguel José de Azanza (the first, incidentally, a Cuban, the second an ex-viceroy of Mexico), had ridden round the city calling on loyal Spaniards to accept pacification.

But this was not the end of the bloodshed. Murat, angered by the death of Frenchmen and hoping to extinguish all germs of rebellion against whatever settlement his Emperor was about to impose, issued from his headquarters on the hill of Príncipe Pío a famous order of the day: 'The populace of Madrid, led astray, has given itself to revolt and murder. French blood has flowed. It demands vengeance.'

The order called for the immediate establishment of a military tribunal, for the summary execution of all Spaniards captured with arms in their hands, the disarmament of Madrid under pain of death, the dispersal of all gatherings of more than eight persons, the burning (elsewhere in Spain) of all villages where a Frenchman had been murdered, the assumption of responsibility in these matters by all employers for their employees, and all abbots for their monks, and the execution of all distributors of 'libels' against France as agents of England. The tribunal was then set up under General Grouchy, an aristocratic officer whose conduct at Waterloo was to cause him, after a lifetime of warfare, to be regarded by Napoleon as his betrayer.

Thus a large number of people were shot, some in the Prado [21], some in the French barracks, some in the Retiro Park, and some near Murat's headquarters on the hill of Príncipe Pío. Precisely how many were shot has been, as always in these circumstances, a matter of controversy. Shooting went on sporadically all night and, again as usual in these circumstances, some innocent people were shot with those technically guilty. A carefully compiled list of Spaniards who died on 2 May and 3 May 1808 gives a list of four hundred names, but there may have been more.[7] Those executed on the hill of Príncipe Pío seem to have numbered forty to forty-five.

Of some of these scenes eyewitnesses survived to tell the tale. Thus a certain Juan Suárez was one of those led out to be shot on the hill of Príncipe Pío: 'already on my knees I too expected to receive the bullets, when I found myself able to slip out of my bonds, fling myself on to the ground and then roll down a narrow ditch. When I got up, bruised, they fired shots at me and even tried to follow me, cutting off my retreat; but I, more agile, gained the wall which I jumped, and succeeded in taking refuge in the church of San Antonio de la Florida' (the new church built by Charles IV in the 1790s for which Goya had painted the frescoes depicting the life of St Anthony of Padua, and in which Goya's own body now lies).

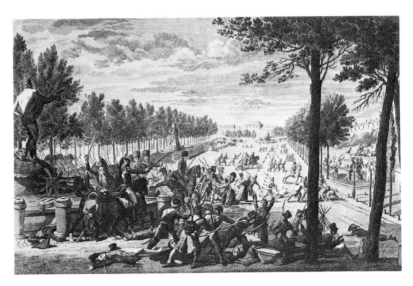

21. *Shootings in the Prado, Madrid 1808.* López Enguidanos

The names of some of those shot on the hill of Príncipe Pío have come down to us:[8] thus there were

Anselmo-Ramírez de Arellano, a mounted police officer; Antonio Martínez, the same; Antonio Mázias de Gamazo, labourer, aged 66 to 70; Antonio Zambrano, labourer; Bernardo Morales, master locksmith; Domingo Braña, aged 44, tobacco porter in the Madrid customs house; Domingo Méndez, a mason working on the church of Santiago and San Juan; Fernando de Madrid, carpenter, at work on the same church; Francisco Gallego Dávila, chaplain of the monastery of the Incarnation, Madrid; Manuel Sánchez Navarro, clerk of the high court; Gabriel López, labourer; José Amador, builder's mate working on the church of Santiago and San Juan; Antonio Méndez Villamil, the same; Manuel Rubio, the same; José Rego Magio, the same; José Loret, shopkeeper; Juan Antonio Alises, groom to Don Carlos, son of the King and future founder of the Carlist claim to the throne of Spain; Juan Antonio Martínez, beggar; Julián Tejedor de la Torre, silversmith in the Calle Atocha; Lorenzo Domínguez, harness maker; Manuel Antolín, royal gardener in the Paseo de la Florida; Manuel García, gardener; Martín de Ruicarado, quarryman working on the Florida

hillside; Miguel Gómez Morales; and Rafael Canedo, of no fixed occupation.

There is, therefore, a good chance that the friar on the left of Goya's picture can be given a name: that of Fr. Gallego Dávila. The church of Santiago and San Juan is still standing now in the Plaza Santiago, between the royal palace and the Puerta del Sol. People working on that site were very likely to have joined a riot taking place in front of the royal palace; they were also in a similarly likely position to be captured by the French soldiery and shot out of hand without cause, simply as a reprisal.

Murat regarded these shootings as exemplary and of great political importance. He seems even to have exaggerated the numbers of those killed. '*La journée d'hier donne l'Espagne à l'Empereur*', he remarked; and at Bayonne, almost immediately afterwards, Napoleon, by a mixture of threats and argument, persuaded both Ferdinand and then Charles to abdicate the throne of Spain. Napoleon then sent his brother Joseph (previously King of Naples) to be King in Madrid and recalled Murat.

The signs were, to begin with, quite promising for this change in Madrid: the Inquisition, for instance, condemned the riots of 2 May without mentioning the subsequent executions and the Infante Antonio, the King's brother who was still in Madrid, expressed his relief that there was at least one army in the world which could hold down a mob. But in fact the news of the executions, and of the abdication of the Bourbons, inspired numerous further riotous outbreaks throughout Spain. By 1 June many priests, peasants and craftsmen, and large sections of the uncourtly or local aristocracies, everywhere from Oviedo to Valencia, took part in what was, to begin with, a spontaneous and unco-ordinated revolt. Townsmen, junior officers and rank-and-file soldiers killed many of their commanders whom they suspected of hedging their bets or of other indecisions. Regions and even cities, bereft of a monarch, showed themselves astonishingly conscious of nationality. Even the Mayor

of Móstoles, a small village fifteen miles west of Madrid, declared formal war on the Emperor of the French. Many acted in the name of Ferdinand, by this time pensioned off in France under the observance of his keeper Talleyrand at the Château de Valençay and in truth openly subservient to the Emperor. The Church was specially active in Spain: bishops and archbishops encouraging their flocks to arms at the call of '*Díos, Patria, Rey*', chiefly because of Napoleon's attack on the Vatican, partly because they anyway saw France and the Revolution as atheistic. Other Spaniards, among them the most enlightened of the reforming generation, sided with King Joseph in Madrid, along with many officials and noblemen who either admired Napoleon or at least thought that he was certain to win. Thus the war of independence, of which the brutality of 2 May and 3 May was a suitable premonition, began its course.

Much of the blame for these disastrous events disastrous for France as much as for Spain – must be attributed to Murat (who was shortly relieved). Napoleon said of him later that he was '*un homme qui regarde le changement [de décoration] à l'opéra sans jamais penser à la machine qui le met en mouvement*'.[9] But nevertheless the Emperor himself was implicated. Murat could not consult him as to what to do on 2 May, but he had an instruction, in the Emperor's own hand only a week before, as to what to do with rioters: 'If the *canaille* stirs let it be shot down.' This was in reply to a letter from Murat who had been complaining that he was having a lot of difficulties with the Spanish Junta. Napoleon had replied that he was ashamed of a general who, with 50,000 men at his back, was getting in the habit of asking for things instead of taking them. Then followed the remark about the *canaille*. Murat had replied as recently as 30 April, two days only before the disaster, that his master's rebuke had stunned him 'like a tile falling on his head' by its unmerited severity.[10]

The ensuing war, with its savagery on both sides, is well established in the historic prejudices of Englishmen, Spaniards and Frenchmen.

As might be expected, the historians of the three countries have scarcely seen eye-to-eye as to what happened. In brief, the French tried to occupy the whole country in the name of Joseph Bonaparte but were checked, a few months after the events just described, at Bailén in Andalusia and then at Saragossa. They even had to withdraw from Madrid. At the end of 1808, Napoleon himself entered Spain with a large army, reoccupied Madrid without difficulty and indeed France soon conquered virtually all Spain except Cádiz. But *guerrillas* (it was then that that word was first coined) held out in the sierras, the French army showed itself ill-equipped for unconventional warfare, and, ultimately, the Duke of Wellington, advancing from Portugal through Badajoz, drove back the invaders between 1811 and 1813. The role of the Spaniards in this victory is, to say the least, controversial, while many of those Spaniards who did keep on fighting in often desperate circumstances were, like the resistance fighters in Europe in the Second World War, fighting for a changed political system rather than for a mere restoration of the Bourbons. The leaders of the *guerrillas*, such as El Empecinado, the famous cobbler's son who terrorized the French in the province of Guadalajara, were mostly poor men. A constitution was prepared in the free city of Cádiz in 1812 which contained many liberal reforms. These, however, only afforded much enthusiasm to the relatively small Spanish middle class. When King Ferdinand came back in early 1814 to Madrid, through no effort of his own – indeed, he always admired Napoleon and behaved in the most cringing manner towards him and Joseph Bonaparte – he was able quickly to trample on the constitution of Cádiz and imprison, exile, or even shoot many of its supporters, as well as persecute those *afrancesados*, or collaborators with the French, who had been rash enough to remain in Spain.

Joseph Bonaparte was an enlightened man who had done his best to rationalize Spanish administration. He abolished the Inquisition, the economic privileges of the Church, the innumerable internal customs duties, all feudal dues and many monasteries. He took part

in popular festivals and worked hard for the public good, especially during the famine of 1811, when the food supplies of the capital broke down. He created the Plaza de Oriente in front of the royal palace (which in after years the most nationalist of Spanish rulers, General Franco, was accustomed to fill with his supporters). But Joseph was never very powerful and, in the provinces, the French military commanders acted virtually independently of him. He was also treated badly by his brother, the Emperor, who incorporated Catalonia and Aragón into France. Joseph represented in Spain a lost cause – unlike the legend left behind in Italy by French administrators and even by the more frivolous Murat, who, after 1808, became King of Naples.

The issues raised during the war of independence were argued over and indeed fought over again and again during the ensuing hundred years. The war itself introduced the army into the political arena in Spain, muddied further the relations between the capital and the regions, and gave ambiguity ever afterwards to the position of the monarchy. By identifying the Church with the masses in alliance against the rationalists and the French, the war re-established the Church as a national institution and for that reason alone rendered the future prospects of liberalism in Spain extremely feeble. Even in the twentieth century, the democratic liberalism voiced by the constitution of Cádiz has not been achieved and indeed would be regarded by the Spanish government of 1972 as, to say the least, impracticable. The war also suggested that, contrary to previous impressions, Spanish nationalism was something which could on occasion triumph over the regional interests of Castille, Aragón, Catalonia and the other provinces

Meantime, the Spanish Empire never recovered from the Napoleonic wars. Left to themselves and forced to choose between two shadows, that of Ferdinand in France and that of Joseph in Spain, the colonies went on to create their own new world, which, after a fashion, survived, despite the efforts of Ferdinand in the next ten years to reconquer it.

3. Goya and Politics

Goya's conduct during these turbulent events is of consuming interest, since he was both an ordinary man who suffered from them and also an extraordinary one who, in recording, transcended them – so diminishing the importance of most other contemporaries, and causing the age to be regarded by many as *his*: 'the age of Goya'. [22A-D]. In years Goya was of the same generation as King Charles IV – two years older, in fact, having been born at Fuendetodos [57], a high and extremely bleak Aragonese village some thirty miles from Saragossa, in 1746. Making his first tentative bow as a painter in 1763, Goya had in 1808 for many years been regarded as the most

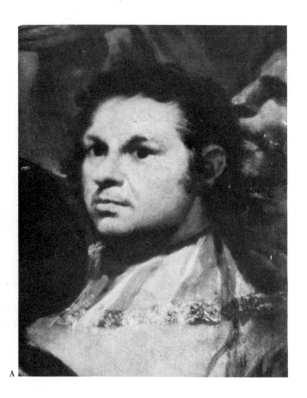

A

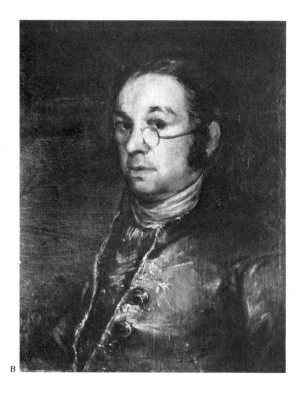

B

talented painter in Spain. He had become painter to the King in 1786, Court Painter of the Royal Bed Chamber in 1789, director of painting at the Academia de Bellas Artes after the death of his brother-in-law, Bayeu, in 1795, and First Court Painter in 1799. As such he was quite rich, lived well, frequented the houses of the aristocracy and himself owned two houses in Madrid.

He had introduced the gentlemanly 'de' into his name in 1786. In recent years he had painted, in some cases many times, most of the main characters in this strange history – Charles III twice, Charles IV and the Queen about a dozen times, and all their family, not to speak of Godoy, Floridablanca, Jovellanos and so on. Most of his other sitters had played active political parts too. Goya's first royal patron, the King's brother, the easy-going Infante Don Luis, had given up the cardinal primacy of Spain in order to marry, and one of his daughters, first painted by Goya as a little girl, married Godoy

22. (A) Self portrait from *San Bernardino of Siena preaching*, 1781. Goya

(B) Self portrait, *c.* 1797–1800. Goya

(C) Self portrait, *c.* 1799. Goya

(D) Self portrait, 1814. Goya

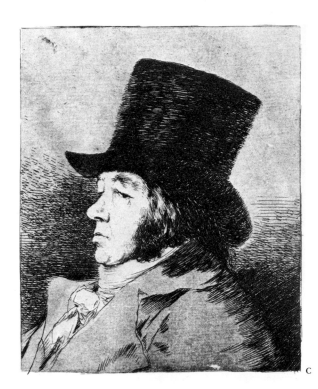

C

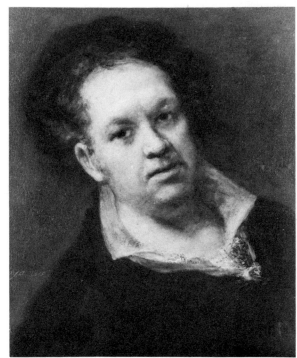

D

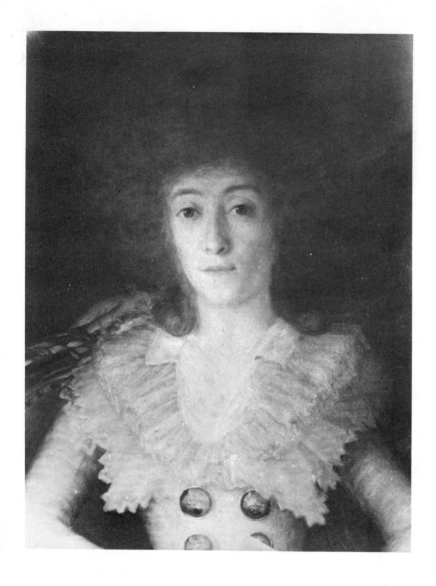

23. *The Family of the Duke of Osuna* (detail of the Duchess), *c.* 1789. Goya

24 *(right). Duchess of Alba* (detail), 1795. Goya

and was once portrayed by Goya, brilliantly, as la Condesa de Chinchón, a somewhat disillusioned young woman. Her brother was painted as Cardinal Primate of Spain at twenty-eight – the same ecclesiastical principality given up by his father. Goya's two most famous patronesses, the Duchesses of Osuna and Alba [23, 24], disputed together, and then with the Queen, for the title of

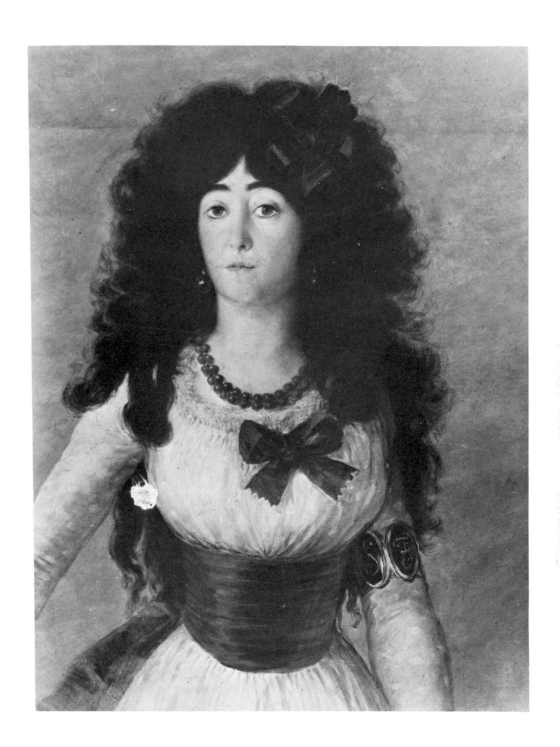

leader of fashion in Madrid, and Godoy later sourly complained in his memoirs that Madrid was so taken up with these rivalries as to ignore the real business of politics. Both, however, were *éclairées*: the Duchess of Alba's grandfather, as Ambassador to France, had for instance been one of the few Spaniards who had read the works of French *philosophes*, had even visited Rousseau in Geneva and afterwards had written to ask him for a set of his works whatever they cost; the Duchess of Osuna's house in Madrid was the centre of French ideas and those influenced by them. Lady Holland had been much impressed by the Duchess's 'great natural talents, wits, eloquence and vivacity'. The Duke of Osuna had led a Spanish army in Flanders in 1794. One of Goya's most famous portraits was that of the French ambassador Guillemardet, ex-physician and regicide, who skilfully maintained the French alliance in the late 1790s. Goya had also even had time to paint Ferdinand as King between the Tumult of Aranjuez in March 1808 and the events of 2 May.

But Goya had already had many lives as a painter since, the son of a not very successful gilder of ultimately Basque origins, he had abandoned his native Saragossa for Madrid in 1773. In Saragossa, he was known as an ambitious and quite experimental painter, often employed by the Church although somewhat smirched by various rivalries with other Aragonese painters, among whom his then more successful brother-in-law, Bayeu, was the most prominent.[11] In Madrid, he had been the painter of sixty-three stylized tapestry cartoons at the royal tapestry factory of Santa Barbara between 1775 and 1792, while the famous neo-classical artist and theorist, Anton Rafael Mengs,[12] was virtual dictator of painting in Spain. (The Santa Barbara tapestry factory had been founded in the 1720s as one of several direct imitations of Colbert's government factories in France.) In 1778 Goya had discovered Velázquez and made engravings of several of his works. Goya began to blossom as a portrait painter after he painted the then first minister, Floridablanca, in 1783. In the course of his last series of tapestries, in the late 1780s, Goya the realist appeared for the first time (with such

pictures as *The Wounded Mason*, *A Poor Family at a Well*, *Winter*, and so on) though even these are still rather idealized, or stylized, suggesting the artist's familiarity with the then fashionable pre-occupation with the noble savage or at any rate the 'virtue' of simplicity. He also depicted a whole series of scenes of life 'before the deluge' of the French Revolution, their delicious and elegant character suggested by their names – *The Dance on the Banks of the Manzanares*, *Blind Man's Buff*, *The Picnic*, *The Swing*. Then, in 1793, with Spain again entering the European wars, a great change had come over Goya: following a mysterious illness, apparently when staying in Cádiz, he became stone deaf. (It now seems possible that the disease, whatever it was, was the consequence of a 'moral and professional crisis', rather than vice versa.) He could therefore be communicated with only by signs or notes. There was an immediate effect on his work: he allowed himself (as he put it in a famous letter to the Vice-Director of the Academia of San Fernando, Bernardo de Iriarte, who had himself been condemned by the Inquisition for blasphemy a few years before) to 'occupy my imagination mortified by my ill fortune . . . and to make observations . . . that normally are given no place in commissioned works, where caprice and invention cannot be developed'. This resulted first in the famous sardonic etchings[13] known as the *Caprichos*, caprices, produced between 1797 and 1798, first published in Madrid in 1799 and which can fairly be regarded as Goya's first really original works of art (though it is legitimate to suppose that in these prints Goya was pretending abnormality in order to disguise his political points); second, in a group of pictures such as *The Fire*, *The Attack on the Diligence*, *The Madhouse* and *The Shipwreck*, which foreshadowed that knowledge of, or feeling for, the abnormal or untoward event for which Goya is now specially renowned. At the same time, Goya was continuing in the late 1790s his admirable, popular, and hence financially most rewarding, series of portraits, mostly of a higher quality than before, as well as completing, in his most brilliantly productive year, 1798, the

frescoes in the church of San Antonio de la Florida, described by one of Goya's most interesting biographers, F. D. Klingender, as '*caprichos* in an ecclesiastical setting'. This was also the time of Goya's friendship with, and patronage by, the Duchess of Alba.

It used sometimes to be said that Goya was a solitary genius sprung amazingly out of the unfertile soil of Aragón during the late eighteenth century and that he single-handedly revived Spanish painting. Without questioning Goya's originality, or the improbability of anyone born at Fuendetodos doing anything worthwhile, or accepting any deterministic interpretation of the relations between the artist and society, that view is misleading. First, Spain in the late eighteenth century was, if behind the rest of western Europe in many ways, a society 'on the move', with far more intellectual liveliness and freedom than it had had a few generations before. While it is evident that Goya's deafness had a major psychological effect upon him and his paintings (as, indeed, the same infirmity had upon his most illustrious contemporary, Beethoven), it is equally clear that the crescendo of the Enlightenment, the French Revolution and the ideas surrounding it, was as great an influence: not only since, despite the strenuous efforts of several of Goya's most distinguished clients, ideas poured in across the Pyrenees, destroying intellectual cobwebs and exciting thought, but also since actual stimuli to new images in painting and other artistic innovations also came. Of course, Goya, like all painters of the time, was the beneficiary of a long tradition of artistic conventions and use of symbols: but in his day, to a hitherto unprecedented extent, innumerable English and French paintings and cartoons came to Spain in the form of prints. These clearly exerted an influence on Goya: 'Through the print, art was internationalized, in the late eighteenth century,' José Gudiol has wisely remarked.[14] It is also known that Goya, when first apprenticed to the painter Luzán at Saragossa in 1763 was, like most young painters at that time, instructed to look at prints.[15] The use of symbolic animals such as the donkey was, for example, a tradition among English political

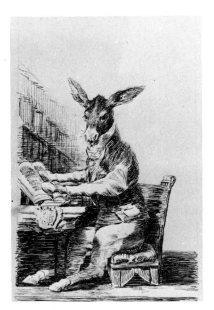

25. Sketch for
Back to his Grandfather,
c. 1799. Goya

caricaturists and that probably affected Goya in his *Caprichos,* where that animal is generally held to represent Godoy [25]. It has often been supposed that prints of the paintings of Gainsborough also influenced Goya in his portraits. Similarly, Piranesi, the engraver of Rome but also of the *Invenzioni, Capricci* and *Carceri,* imaginary and mad gaols, begun in 1745, together with Magnasco, also probably influenced Goya, communication being apparently effected through the collection of prints of Sebastián Martínez, the Treasurer-General of the Council of Finances at Cádiz, with whom Goya was staying during his illness of 1793 and with whom he remained for six most critical months. (A collection of Piranesi prints was incidentally among the items listed in an inventory of Goya's own goods dated 1812.)

It is possible that the collection of Sebastián Martínez was the inspiration for some of Goya's most famous works. Perhaps, for example, he possessed collections of the prints of Jacques Callot, the seventeenth-century engraver from Strasbourg who published a series not only, as is well known, of *Grandes Misères de la Guerre* but also (like Giovanni Battista Tiepolo in the mid eighteenth century) a less ambitious series of *Capricci,* not to speak of an *Attack on the Diligence,* a version of which Goya also produced among the paintings he seems to have completed at this difficult time [26, 27]. (Magnasco also did an *Attack on the Diligence*; the reason for such concentration on this theme was doubtless that it was the way that most courtly people at that time of peace encountered violence.) Perhaps a list of the collection of Sebastián Martínez would throw much light on Goya's process of conception. (Professor Sánchez Cantón has guessed that Goya himself later possessed a set of Callot's *Grandes Misères de la Guerre*).

Another example of the influence of French ideas in Spain during the 1790s was the formation of a group called the Acalophiles, or lovers of ugliness. These writers and critics, among them Goya's friend, Leandro Fernández de Moratín (who also made a study of English caricatures) affected an interest in the hideous in order to

criticize a political order based on harmony. Presumably the *Caprichos* were one consequence of this as they also were of the ideas of the seventeenth-century writer Quevedo.

It is indeed scarcely possible to imagine a painter producing such an immensely varied corpus of pictures as Goya did in any other age before our own. Thus Goya is a man who illustrated as well as anyone the *douceur de vivre* regretted by Talleyrand of pre-1789 Europe: his *Swing*, in the collection of the Duke of Montellano and in which it is said the Duchess of Alba appears for the first time (on the swing itself) has almost as much charm as Fragonard's; but his pictures of madness, cruelty, and cynicism, indeed his universal knowledge and interest, reflect a man living in most testing times and one also who knew well the harshness of country life

26. *Attack on the Diligence,* pub. 1636. J. Callot

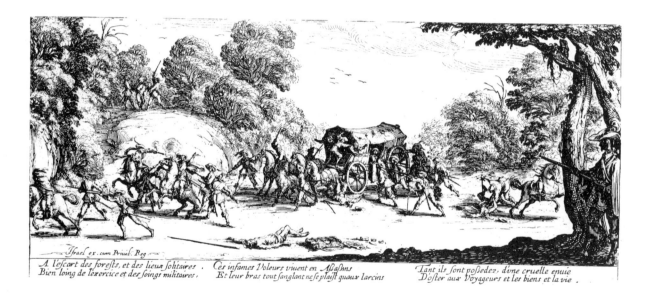

Ifrael ex. cum Priuil. Reg

A l'efcort des forefts, et des lieux folitaires .
Bien loing de l'exercice et des foings militaires ,

Ces infames Voleurs viuent en Affaffins
Et leur bras tout fanglant ne fe plaift quaux larcins

Tant ils font poffedez, d'vne cruelle enuie
D'ofter aux Voyageurs et les biens et la vie .

in Aragón as well as the softness of courtly life in Madrid, Arenas de San Pedro or at the Osunas near Barajas.

But in 1808 Goya, personally, must have seemed a lonely figure, whose best years were behind him. His most glittering patron, the Duchess of Alba, had died at forty in 1802, the Duke eight years

27. *Attack on the Diligence,*
c. 1792–1800. Goya

before that. The Duke of Osuna had died in 1807, and the Infante
Don Luis had been in his grave almost twenty years. Jovellanos,
along with other liberal friends, had been in disgrace and even
their movements had been curtailed since 1800. Even Goya him-
self, despite his salary as First Court Painter, had not been in royal

favour since 1801, the year after he had painted the well-known picture of the royal family, which, as is now clear from letters of the Queen to Godoy in respect of sketches for the main picture, seems to have much pleased them. The reasons for this absence from the court are not known. Probably it was a consequence of the disgrace of Jovellanos and other *ilustrados*. It is possible that the death of the Duchess of Alba in 1802 distressed him, though, apart from Goya's depictions of the Duchess, in particular in the *Caprichos* (and in particular again in the engraving, *Dream of Lies and Inconstancy* [10]), there is no sure guide to the character of their friendship. He also had some difficulties with the Inquisition over the *Caprichos*, and seems only to have got over these by giving the plates of that series to the King though in return he received a pension for his son. Anyway, during the years since 1800 he was somewhat less productive than before and perhaps calmer. Godoy, it is true, continued a useful patron; the two *Majas*, naked and clothed, for instance, which were apparently painted between about 1800 and 1805, were in his palace in 1808.

In 1808, Goya lived in the Calle Valverde, no. 15. The street, though not the house, survives behind the telephone building. Thus he could not have been, as is sometimes said, a witness from his actual windows of the events of 2 May; nor could he have seen the shootings of 3 May from any house of his own (he did not buy the *Quinta del Sordo*, 'the country house of the deaf man', until 1819). But where exactly he was on 2 May and 3 May is not known. The first French soldier (a mameluke) to be killed in the Puerta del Sol was apparently shot by a bullet coming from a window of the house of a certain Gabriel Bález, who was a relation by marriage of Goya's daughter-in-law. Goya's son was also apparently living very close to the Puerta del Sol. No one can say whether or not Goya did indeed, as verbal legend has often suggested, walk the streets and, for the first time in his life, at 62, silently (for, presumably, being deaf he could have heard no shooting) see scenes of heroism and atrocity. Some of the etchings in the series the *Disasters of War*

28. I saw it, c. 1810. Goya

seem to reflect direct observations; but perhaps this is less important a point than it seems. Goya doubtless knew of the horrors of war from eyewitnesses even if he did not see them personally. Did he see the flame depicted in *The Fire*? The picture is nonetheless realistic even if he did not do so. He felt, if he did not see. But, at the very least in the two etchings of the *Disasters of War* entitled *I saw it* [28] and *That also*, Goya is generally held to have been depicting something which he knew about – and perhaps in *This is worse*, Disaster No. 37, on which he noted the words 'the man of Chinchón' *('el de Chinchón')*: Chinchón, a village to the south east of Madrid, had been given as a benefice to his brother by the Condesa de Chinchón, Godoy's wife and daughter of the Infante

29. Map of Madrid (detail), *c.* 1780

A. Royal Palace
B. Puerta del Sol
C. Goya's house in the Calle Valverde
D. Church of S. Francisco el grande
E. Palacio Osuna
F. Palacio Alba
G. Casa del Príncipe Pío

H. Montaña:
 probable site of executions
J. Possible buildings in
 background of *The Third of May 1808*
K. Prado (the street)
L. Pradera de San Isidro
M. Ermita de San Antonio

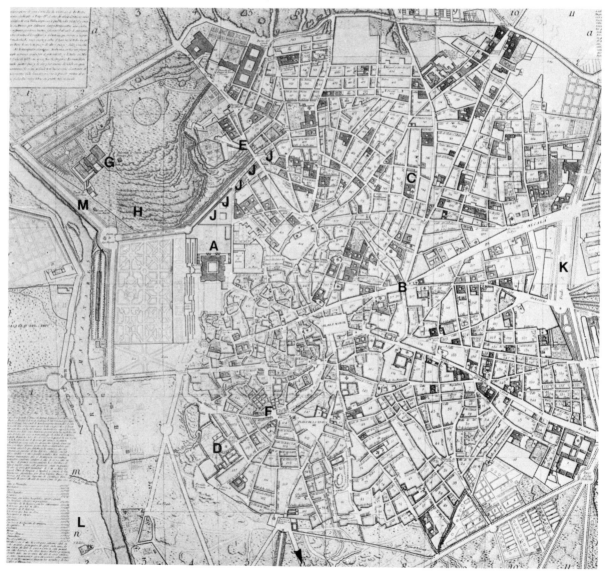

To Aranjuez

Don Luis. He must also have seen how ironical it was that the very Florida quarter of Madrid where he had sketched picnics and dancing for his tapestry cartoons, should become a background for his most violent political painting. The hill of Príncipe Pío was, after all, only a short walk from the Albas' summer house, the 'Palacete de Moncloa', already bought by the King, and from the palace of the Duke of Osuna. Further, as has been seen, the hill itself had been depicted by Goya already, on the left of his most engaging of *fêtes champêtres*, *La Pradera de San Isidro*, that ambitious canvas in the style of Velázquez which Sánchez Cantón (with some exaggeration) has described as Goya's 'only landscape' [12]. Finally, the church of San Antonio de la Florida stood just at the bottom of the hill, the other side of the French soldiers [29]. May, too, the time of the executions, is the month of the celebration of the famous Madrid fiesta of San Isidro.

Goya in 1808 had been married for thirty-five years to Josefa Bayeu, sister of his onetime mentor in Saragossa [30]. Of the Señora de Goya, almost nothing is known. By her, he had had several children (older biographies say twenty, modern, six) of whom only one son, Xavier, survived, married by now with a son of his own, Mariano, born in 1806. Goya's father, mother and sister were dead, but his brother was still a priest at Chinchón.

About Goya's political views in May 1808 it is impossible to be precise. Did he, for example, ever believe, with the then captain-general of Barcelona, the aged *ilustrado* Conde de Ezpeleta, that 'Spain could only be saved by the Emperor Napoleon'?[16] Goya's friends were men of the Enlightenment and several, such as the poet, Meléndez Valdés, Bernardo de Iriarte and Moratín, or the ex-Secretary to the Inquisition, Canon Llorente, sided with Joseph Bonaparte: Moratín became royal librarian, Iriarte and Llorente counsellors of state. The creator of the *Caprichos* was evidently a rationalist; and the still powerful Inquisition and the ignorant and lazy priests and monks of old Spain were plainly repellent to him. But the shootings, the sackings, the rapes, and the brigandage

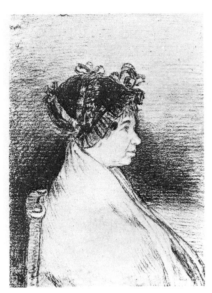

30. *Josefa Bayeu*, 1805. Goya

brought to Spain by the French, equally obviously, judging from the *Disasters of War*, appalled him. An old story (given some credence by its repetition by the distinguished art historian Enrique Lafuente Ferrari) alleges that Goya began his depiction of warfare the day after the shooting in Madrid: his manservant asked him why he painted the barbarities of the French. 'To tell men eternally not to be barbarians' Goya is supposed to have answered. It is also now known that in the middle of the Napoleonic war he set out with one companion (his wife by then being dead) to try and reach a 'civilized country'. He was sent back by police in Estremadura. In the *Disasters of War*, as in the *Caprichos* and some of the paintings of the 1790s, not to speak of those of the time of war itself, there is an undoubted pessimism that contrasted with the hopeful spirit of the Enlightenment. The *Disasters of War* are not, to put it mildly, the work of a man who believes that human nature is essentially good. Nor do all his paintings reflect anti-clericalism. In *The Third of May*, as has been seen, one of the condemned men is a friar; the series of paintings depicting Brother Pedro de Zaldivia outwitting the bandit Maragato shows a monk who is both clever and brave; Goya knew, of course, that Feijóo, who more than anyone modernized Spanish thinking in the eighteenth century, was a Benedictine monk; and he evidently remained on terms with his brother Camilo, the priest. Some of his religious paintings, such as the frescoes in the church of San Antonio de la Florida (1789) or the *Last Communion of St Joseph de Calasanz* (1819) are of the first rank. The probably conscious religious undertone to the composition of *The Third of May* evidently testifies to the fact that Goya, like most people of his age, certainly like most Spaniards, was never able to shake off the Church's hold, regardless of how much he may have had doubts about the truth of her doctrine.

There are, in fact, no exact records or at least none have as yet been discovered about Goya's state of mind at this time. So his attitude to many of the happenings after May 1808 is a mystery, as indeed is his attitude to many other events. Can the opinion of

Malraux on the *Disasters of War* be really accepted? Namely, that they resemble the 'sketchbook of a communist after the occupation of his country by Russian troops'?[17] For, whatever precise political feelings Goya may have had about Joseph and Ferdinand (and, like those of most educated Spaniards, it is obvious that they were at times ambiguous), it is clear from the *Disasters of War* that he was appalled by what he saw of the conflict: no one could draw the frightful *For this you were born* without a sense of outrage, less in respect of a particular cause than because of man's inhumanity to man [31]. Many of Goya's past sitters, of course, were involved in this holocaust including some of the children he painted so well in

31. *For this you were born,*
c. 1810. Goya

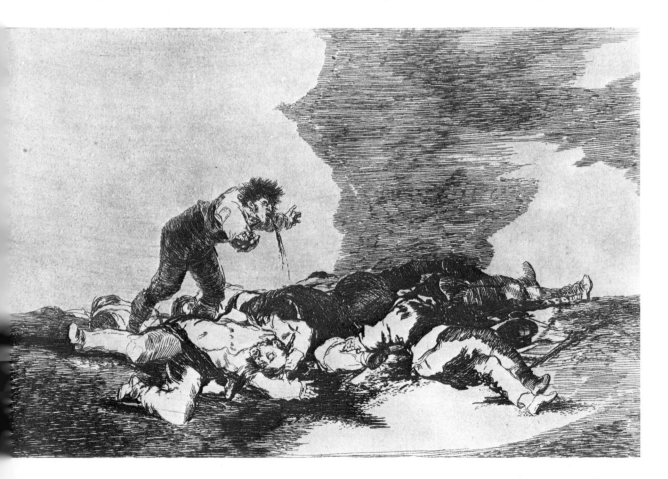

the 1790s; while in October 1808 the *Gaceta de Madrid* (11 October 1808) shows that Goya subscribed for a great quantity of cloth for the army of Aragón. The general comment made by Goya's old Saragossa friend Zapater is no doubt specially relevant to the events of the war: 'a more or less adventuresome mind, an intelligence and head more or less addicted to novelties, always united with his family and to the society whose defects he laughs at and even satirizes, while never in fact abandoning the religion of his parents, which he invokes on all occasions.'[18] Goya had a complicated personality: he was both a friend of the Enlightenment but also a careerist; a man interested in social advancement but horrified, as the *Caprichos* suggest, by the deceits and artifices of society. It is only too likely that he admired Napoleon (who perhaps is represented symbolically in the famous *Colossus*, or *War*, painted some time between 1808 and 1812) while disliking French soldiers. Perhaps, too, it is possible to over-intellectualize: Goya had little formal education; most of his ideas were picked up from talk in the enlightened aristocratic circles which he frequented in the 1780s; and Pierre Gassier and Juliet Wilson remind us that partridge shooting may have been more intoxicating to him than the act of creation.[19]

Goya anyway stayed in Madrid in 1808 and indeed, during the whole period between 1808 and 1814 while Spain was racked by war, he was mostly in the capital. In the autumn of 1808, however, he went briefly back to Saragossa, which, during the summer, had been held heroically against the French by its citizens under Palafox. While there, he painted Agostina, the famous heroine of the city's defence, a picture destroyed by the French in 1809. Goya thus saw directly some of the consequences of the violent patriotism of his native province, though, presumably, he saw no actual fighting, since the war had temporarily passed away from Aragón. Probably during the course of the second (and, so far as the French were concerned, successful) siege of Saragossa, two minor artists of Madrid, Juan Gálvez and Fernando Brambila (actually a Neapolitan by birth), at some personal risk, sketched scenes of war, which became

a series of etchings, the *Ruins of Saragossa*, which almost certainly influenced Goya's own *Disasters of War*; see, for instance their depiction of the carpenter, Josef de la Hera, killing a bushy-looking Frenchman, who seems a most Goyaesque individual [32], which was certainly carried out before Goya's designs. If that is indeed so, their contribution to Goya's work is obviously considerable.[20] In

32. *The carpenter, Josef de la Hera, killing a Frenchman,* 1814. J. Gálvez and F. Brambila

33. *Ruins of Saragossa*, 1814.
J. Gálvez and F. Brambila

one of their prints, these painters are to be seen sketching away in the background after what must have been a most sanguinary encounter [33].

It is uncertain when exactly Goya returned to Madrid, but he must have been back before the dramatic two-day defence of Madrid against the French in December, when Napoleon himself was in command. These days were among the most dramatic and disagreeable in Madrid's history. Few behaved creditably. The Junta of Madrid, though supported by much patriotic feeling among the populace, mismanaged the defence of the city and surrendered in a craven fashion – very different to what had happened in Saragossa.

Napoleon then extracted, through liberal terms, an act of capitulation, which, however, he promptly broke on a trivial pretext. There followed many arrests and even three deportations to France among the leading *madrileños*: the Marqués de Santa Cruz, the Prince of Castelfranco and the Conde de Altamira, of whom the first had been one of Goya's patrons in the 1780s (though not, it seems, a sitter) and the last had been painted by Goya in those old days. As many members of the council of the Inquisition as were in Madrid were also arrested. At the same time, Napoleon secured the adhesion, by a mixture of promises and threats, of many prominent men, and promulgated many admirable reforms. In these weeks of late 1808, therefore, emotions, quarrels and ambiguities were aroused in Spain which have never been properly soothed. It is easy to imagine Goya, already perhaps sketching scenes of the war, admiring Bonaparte's efficiency in carrying out what no Spanish monarch had dared to do or wanted to, but deploring his brutality, and, who knows, wondering whether the two were not inevitably connected.

In Madrid, Goya continued to paint portraits, including some of the occupying French officers, and later even one (though only apparently from a print) of Joseph Bonaparte. (This painting – *Allegory of the Town of Madrid*, painted in 1810 and now in the Ayuntamiento de Madrid – twice had its central motif painted out: today the painting is made to commemorate the Second of May 1808 without recalling that it once celebrated Joseph Bonaparte and, later, the constitution of 1812. For in that year Goya's portrait of Joseph was over-painted and substituted with the word 'constitución'.)[21] Goya also presided, with his fellow painters Napoli and Maella, over a committee which, at Napoleon's order, dispatched fifty mostly inferior paintings to Paris as part of the loot of war, from suppressed monasteries or confiscated estates. He accepted the dark red cravat of the Order of Spain awarded by the French to collaborators (nicknamed by patriotic Spaniards the 'aubergine'), and painted several of these later much maligned *afran-*

cesados. But to balance these scarcely patriotic actions, in 1812, he three times painted the Duke of Wellington, after the French had retreated and during Wellington's first stay in the capital. He also painted the two beautiful pictures of bullet-makers and gunpowder-makers in the Sierra de Tardienta, to the north-east of Saragossa, which contrast so well the calm forest with the menacing activity. These pictures must have been inspired by things that he saw on the way to Saragossa or on the way back in 1808. Goya in truth simply carried on his profession as painter during these harsh years between 1808 and 1814 and it is perhaps anachronistic to expect that, in those days, he could have held aloof from the French. During the famine in Madrid of 1811 Goya was doubtless as short of food as anyone else in the capital.

In addition he painted twelve 'horrors of war', in oil, now mostly in the collection of the family of the Marqués de la Romana, de-scendants of one of the leading patriotic generals of the war, and, as well as a large number of other drawings, drew the sketches which became the foundation of the *Disasters of War* – the title given to that collection of engravings by the Academy when they published them in 1863; though Goya named them '*The Fatal consequences of Spain's Bloody War with Bonaparte and other emphatic Caprichos*'. These ferocious engravings were first known about 1820 and may have been done not long before, from, however, drawings mostly completed during the war: one or two of the plates were given the definite date 1810.

This series is probably the most vivid attack on war ever made. They are perhaps less anti-French than they seem at first sight: often French soldiers are seen in terrible circumstances, even if perhaps not so terrible as those in which the Spanish patriots or civilians find themselves. The only heroic picture depicts Agostina, who was also depicted, and in almost the same stance, by Gálvez and Brambila. Doubtless Goya's oil painting of that heroine was similarly composed. In the sequence of plates devoted to rape, it admittedly seems to be the bushy-moustached French soldiers who

34 (below). *A Nightmare*,
c. 1799–1808. Goya

35. *That's tough!* (detail),
c. 1810. Goya

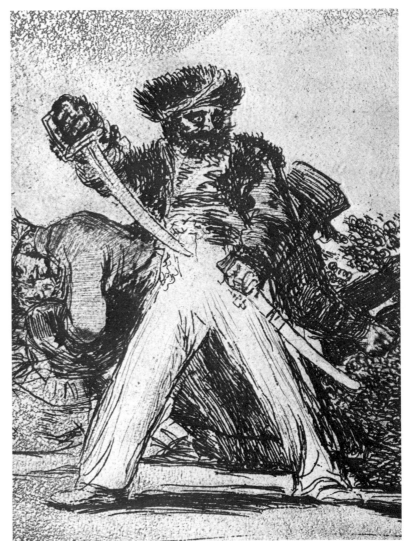

are always in the wrong [35]. They are figures, incidentally, not far
removed from the bushy nightmare in the collected drawings [34].
But there is also the plate entitled *Populacho*, in which the populace
are shown lynching an *afrancesado* nobleman, perhaps depicting
the Marqués de Perales in Madrid [36]; and that in which the
French are being hung by, it would seem, the order of the desperate

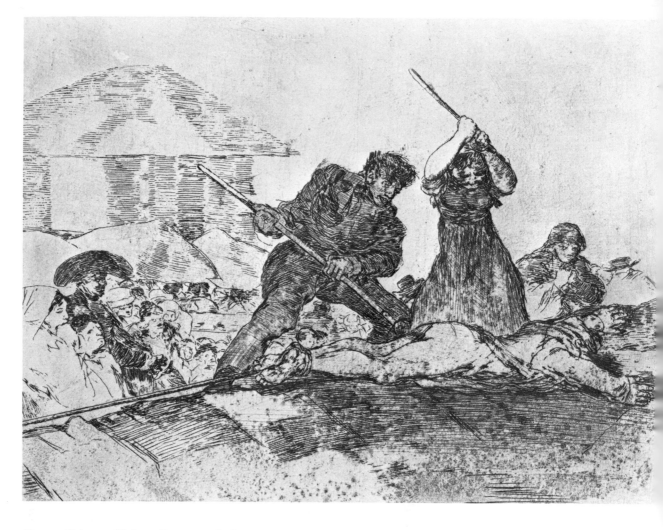

36. *Populacho, c.* 1810. Goya

Canon Calvo at Valma. In general, these plates simply bemoan the evil of war without making any specially patriotic comment.

In 1814, before Ferdinand returned in triumph to Madrid in the wake of the Duke of Wellington's victories, and those of the Spanish partisans, Goya asked for financial assistance to 'perpetuate in painting' the war against Napoleon and, obtaining it, painted *The Second* and *The Third of May*.[22] (The request went to the Regency, of whom one member, Cardinal Borbón, had already been twice

painted by Goya.) Both pictures are believed to have been intended to be shown on triumphal arches erected to celebrate the return of King Ferdinand – in the once traditional manner, followed by Rubens in his similarly decorated arches celebrating the entry of Ferdinand of Austria into Antwerp in 1635. It is, however, not known whether they ever were so exhibited. For the artist had to appear before Ferdinand's 'purification' tribunal and account for painting King Joseph, for his oath of loyalty to that monarch and for his acceptance of the 'aubergine'. He said that he had never worn the latter and that he had painted Joseph Bonaparte from an engraving, not from life. Ferdinand is reputed to have said that Goya deserved execution, but since he was a great painter, he could be acquitted. Doubtless that remark, even if apocryphal, represented the truth of the situation. Goya anyway was found to be in the least compromising of categories in the 'purification' and, in consequence, suffered nothing, except presumably anxiety for a year. But this perhaps explains why there is no certainty that these paintings were exhibited at the time; at the death of Ferdinand in 1834 they appear to have been only among the reserves of the Prado, though they were seen by Théophile Gautier in 1839. They first appeared in a catalogue of the Prado in 1872.

Goya must have seemed in 1814 to have been nearing retirement. His wife, Josefa, had died in 1812 and he was now living with a distant relation, Leocadia Weiss, as his housekeeper: the truth of their relationship is not certain. But Goya's last years were extraordinarily full and varied. He painted numerous further portraits, although these are generally held to be a little less fascinating than those done in the late 1790s. He drew many vigorous and interesting sketches which might have been turned into very good pictures had he had time. He embarked on a series of engravings to illustrate a history of bullfighting by the father of his old friend Moratín (these were known as *Tauromaquia*); and afterwards he produced what seem to resemble a new version of the *Caprichos*, the surrealistic *Disparates*, or extravagances, though at first published as

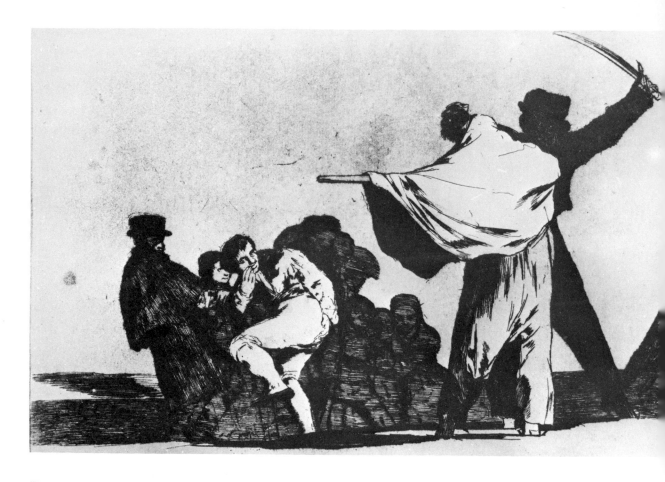

'Proverbs'. Of these, the imagery of the *Disparate Conocido* [37] reflected in composition (and perhaps in other things) *The Third of May*: a crowd faces two contraptions of wood and cloth, symbolizing reaction and despotism. Most of the crowd are still afraid of scarecrows. But the man in the centre has seen the fraud. (This theme of scarecrows crops up elsewhere in Goya's work – for instance, in *What a Tailor can do* in No. 52 of the *Caprichos* and in the *Disparate de Miedo*, No. 2 of the *Disparates*.) He also painted at this time several new religious pictures, in particular the famous *Last Communion of St Joseph de Calasanz*. Then, after another serious and equally mysterious illness, or perhaps another bout of

the same one which occurred in 1792–3, in 1819 (the year the Prado was opened as a museum), Goya went to live in the *Quinta del Sordo*. There he painted the famous Black Paintings which, in 1873, were taken off the walls through the munificence of the German Baron d'Erlanger just before the house was destroyed, and sent, ultimately, after an unsuccessful showing in 1878 at Paris, to the Prado in 1882. These paintings are often thought to be fantasies: in fact, many of them reflect a real impression of a winter's night in Aragón.

Finally, in 1824, when, once more in the wake of a French army, but this time a conservative one under the Duc d'Angoulême, reaction returned to Spain after the brief sunlight time of the Constitution of Riego (1820–23), Goya went at the age of seventy-eight to live, with royal permission, at Bordeaux among many other liberals or *afrancesados*, though, since he first went ostensibly for his health, he kept his salary and title as First Court Painter. The reason, however, was undoubtedly his disillusionment with the 'white terror' that spread through Spain and, perhaps, his apprehension that, even at his age, and even with his distinction, he might be caught up by it. He spent two months in Paris. Goya painted further at Bordeaux but, on the whole, in a somewhat softer style. He painted miniatures. He also carried out several remarkable lithographs (lithography having just been developed in France) and some sketches for a new series of *Caprichos*. Goya died at Bordeaux in 1828 at the age of eighty-two. His body was transferred to San Isidro in Madrid in 1901 and to San Antonio de la Florida in 1928. His skull, however, was mysteriously removed from the grave in Bordeaux some time in the nineteenth century; even more mysterious, a picture was once in circulation depicting this skull. That, too, has since vanished.

It was many years before Goya was regarded universally as one of the geniuses of the Napoleonic age. This was partly perhaps because most of his best paintings were in Madrid and even there in private hands, and Madrid was in the nineteenth century the

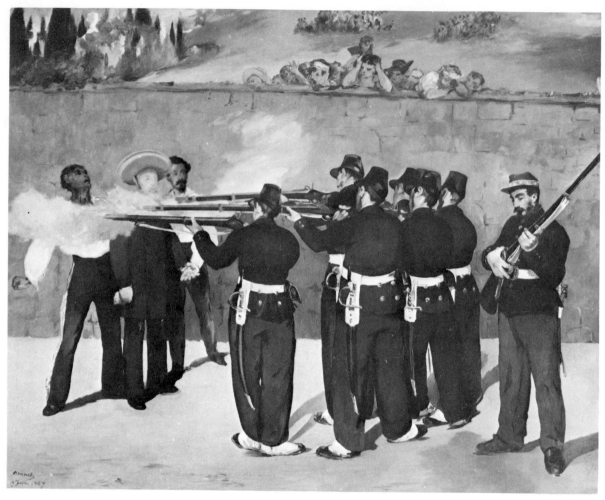

least frequented of capitals. The *Caprichos* were known in the north of Europe (being much admired by Delacroix) but *The Disasters of War* were scarcely known at all until the 1860s though Gautier saw and admired them (being perhaps the first critic to point out the similarity with Callot) in 1840. In addition, the mid-nineteenth century disliked the gloom and sombre tones of much of Goya's best work. But the Impressionists gained much from him, in particular Manet who visited Madrid in 1865 and whose *Execution of the Emperor Maximilian* [38] in many versions, has

38. Execution of the Emperor Maximilian, 1867. Manet

obvious affinities with *The Third of May*, though, as often pointed out, it is certainly more chilling, detached and metaphysical than Goya's painting. (The depiction of the spectators in the Mannheim version also has much, as the Swedish critic N. G. Sandblad points

39. *La Tauromaquia*, No. 13, *c.* 1816. Goya

out, in common with the spectators in one of Goya's prints in the *Tauromaquia*, No. 13. [39]). Other paintings by Goya influenced Manet, such as the *Balcony*, and the *Pradera de San Isidro*, while Renoir also very much admired the hints, rather than detailed depictions, which characterized Goya's portraits. Even so, the late Victorians, creatures of an optimistic time, found much of the most interesting work by Goya too despondent, anarchic and odd. This hostility was expressed by Berenson, keeper of the conscience of Italian art: 'with Goya the modern anarchy begins.' Only in the

twentieth century, an age as tumultuous as that of Goya's own, with its frequent heady moments of wild hope, its frequent dark times of oppression and cruelty, and its preoccupation with madness and superstition, has Goya been placed in the pre-eminent category where he now stands. These prejudices were reflected in prices. The National Gallery bought the admirable portrait of Isabel Cobos de Porcel for a mere £400 in 1896 (at a time when Murillo was fetching thousands). Even in 1957 a study for the portrait of Godoy in the Academia de San Fernando changed hands for a mere £2,800. But in 1961, the National Gallery in London paid £140,000 for the Duke of Leeds's *Duke of Wellington*.

Ironically, Goya's first known paintings, *The Virgin and St Francis* and the *Virgin of the Pillar*, in the church of Fuendetodos, were destroyed during the Spanish Civil War, while *The Second of May* and *The Third of May* were, with other paintings, taken from Madrid to Valencia, thence to Barcelona and finally to Geneva. During these journeys one of the lorries carrying *The Second* and *The Third of May* had an accident and the two pictures were slightly damaged.

4. Art and War

The Third of May is certainly one of Goya's greatest pictures and expresses, as it were, the whole, enormous range of his work. The gloomy colours and impression of the background so suggestive of disaster foreshadow the frescoes of the *Quinta del Sordo*; the arrangement of the crowded canvas recalls Goya's previously most ambitious work, the frescoes in San Antonio de la Florida. Nevertheless, the most important point about the picture is that, from the point of view of time of composition, it certainly follows not only the *Caprichos* but also the *Disasters of War*, to which it is closely related in composition and in intellectual intention. One of the latter engravings, No. 2, *Con razón o sin ella* (*With reason or without it*) [40], seems exactly to foreshadow *The Third of May*, though in the print the central figure is fighting the French with a knife. Another print in this terrible series which in composition bears on *The Third*

40. *With reason or without it,*
c. 1810. Goya

Y no hai remedio.

of May is No. 15, *Y no hay remedio (And there is no remedy)* [41], where French rifles are plainly seen once again in action. The massacre in No. 26 *No se puede mirar (One cannot bear to see this)* [42], might have depicted the shooting on the third of May 1808, while the pile of bodies seen in No. 22, *Tanto y más (Even worse)* [43], may very well depict the Montaña del Príncipe Pío. There is also an

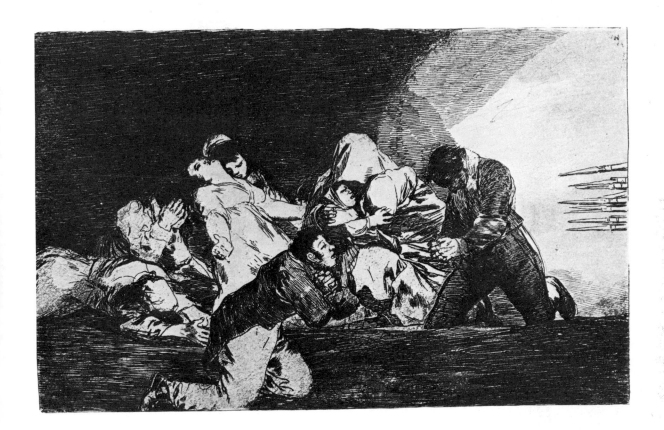

42.·*One cannot bear to see this, c.* 1810. Goya

43. Sketch for *Even worse*,
c. 1810. Goya

44 *(below)*. *An Execution*,
1810. Goya

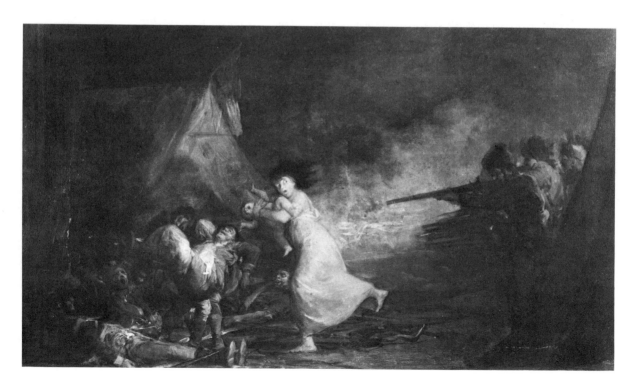

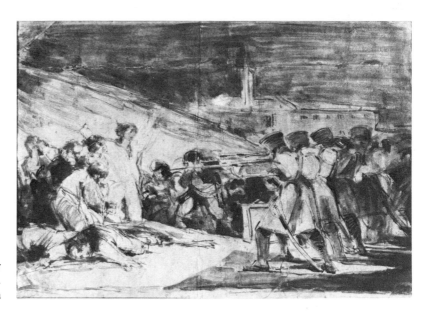

45. Sketch for
The Third of May 1808.
Attrib. Goya

46. Sketch for
The Third of May 1808.
Attrib. Goya

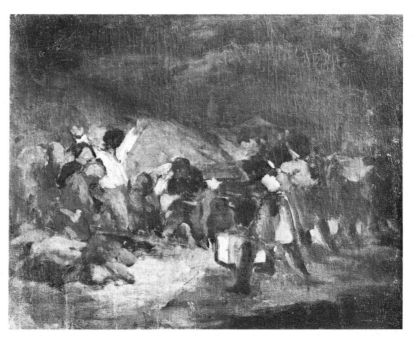

oil painting of an execution, dated 1810, in which once again the composition, with the light on the victim and the executioners left anonymous, foreshadows *The Third of May* [44]. It is instructive that there are no such similar foreshadowings of *The Second of May* – and it is also interesting that none of the preliminary drawings by Goya in the Prado exactly reflects these compositions. (A drawing purporting to be a preliminary sketch of *The Third of May*, in the possession of Pierre Jeannerat in London, is not universally regarded as being by Goya and it seems as if it might be posterior in date to the painting [45]. Similarly, the 'preliminary sketch' on canvas of *The Third of May*, belonging to the Hispanic Society of New York [46], though probably not posterior to the painting, is not now regarded as by Goya. But this may not be correct since there were many instances of Goya carrying out a smaller painting as a preliminary to his larger compositions, and a 'preliminary' painting for *The Second of May*, in a private collection in Madrid, is generally accepted as genuine.)

At the time the picture must have seemed most startling, though no contemporary accounts seem to exist of any impression made by it. (The first actual description of it, indeed, appears to date from 1839 when Théophile Gautier saw it 'relegated without honour to the antechamber' of the Prado: he described it as a painting 'of an unbelievable verve and fury'.[23]) Artists of previous centuries had frequently depicted war but, on the whole, they had dignified it, since they usually sought to please a princely victor, to embellish a room or to honour God. The depths of human behaviour were rarely even hinted at. In this depiction of a patriot dying, the '*beau idéal*' of painting for pleasure or 'life enhancement' is, as Pierre Gassier and Juliet Wilson put it, finally also killed. Occasionally, in the past, as in the famous sixteenth-century Flemish tapestry depicting the Battle of Pavia at Naples, or in some of the paintings of Bruegel or in Callot's etchings, some of the confusion and real destruction of conflict was allowed to come through. Callot showed

47. *An Execution*,
published 1636. J. Callot

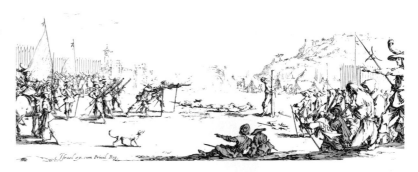

at least one actual execution [47]. But his men are small, far away, expressionless, and, if visual illustration were all that remained to give knowledge of the battles and troubles of the centuries before the French Revolution, there would be little reason for the belief in progress; the past would seem (especially from the vantage point of the twentieth century) much too golden. It is true that suffering was often depicted by painters before Goya, but usually the sufferer was Christ on the cross or the martyrs, rather than an ordinary and unknown mortal. Ribera six times painted St Bartholomew being flayed alive, but his fear and agony is not so evident as that of the man in the white shirt in *The Third of May*; or perhaps, to be pious, St Bartholomew was not afraid, since he believed in God, while the man depicted here is, since he is not so sure.

The Third of May seems in all these ways to break new ground much more than does *The Second of May*, which keeps more to the old stylized tradition: are those horses really dying, are those men really fighting, or are they part of the crowd in an opera? The realism of *The Second of May* is less emphasized than in that of its companion, where numerous clever devices, such as the facelessness of the soldiers, are employed to give a greater immediacy. There is an element of Rubens in *The Second of May*, in particular of his *Centaurs fighting Lapiths* in the Prado, with which Goya may very well have been familiar.

Still, if there are few precedents in painting for *The Third of May*, there are among caricatures – of which Callot was, in fact, himself

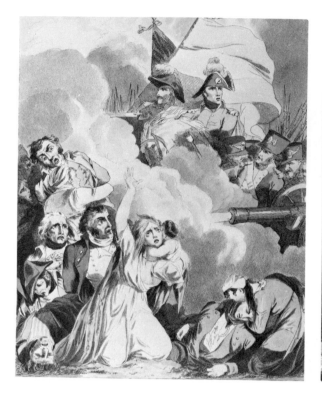

a forerunner. Hogarth depicted reality but not war, since he did not know it. Caricaturists, having in some ways a much greater freedom than painters, had in the eighteenth century not hesitated to show violent scenes and, in particular, the caricaturists who attacked the French Revolution had done so. These were, of course, mostly English and many of their prints came to Spain in the nineteenth century with the English armies. These propaganda prints were possibly a direct influence on Goya, particularly on *The Third of May*, as argued by Professor Gombrich, who has suggested a direct connection between Goya's work and the cartoons of R. K. Porter, a painter who accompanied Sir John Moore to Salamanca in November 1808 and whose caricatures were apparently circulated in Spain.[24] Gombrich argues even that 'the protruding eyes and violent distortions of the victim's face, the effective contrast between

48A. *Buonaparte massacring 3,800 men at Jaffa.* After R. K. Porter, 1803

48B. *Buonaparte massacring 1,500 persons at Toulon.* After R. K. Porter, 1803

the pointing guns and helplessly kneeling figures, the abbreviated forms through which the masses of similar victims are conveyed while attention remains focused on the principal scene' of *The Third of May* derived from Porter. [48A, B]. The image, that is, suggested by Porter, or the composition of the picture, influenced Goya. It is even possible that Porter's battle scene, *The Storming of Seringpatam* may have suggested something to Goya. It is thus obvious that whether or not Goya was the eyewitness of one or other of the scenes he depicted, he painted *The Third of May* within the tradition of the 'atrocity imagery' of the time.

There is, similarly, perhaps a connection between Goya's *Second of May* and the lithograph of H. Jannin [49] of the terrible battle of Aspern-Esling on the Danube, in 1809, in which Marshal Lannes was fatally wounded. The stance of the horse on the right centre of the picture is indicative, while the possibility that Goya saw the lithograph is enhanced by the fact that Marshal Lannes had been the French Commander who earlier in the same year had finally conquered Saragossa; while Aspern-Esling was the first really big defeat of Napoleon and must have been talked of in Madrid. The

49. *Battle of Aspern-Esling,* 1809. H. Jannin

contribution which may have been made to Goya's work by Juan Gálvez and Fernando Brambila has already been discussed.

The absence of any drawings or sketches for any of the *Disasters of War* prints which are connected with *The Third of May* is curious and may be no coincidence – lending support, in fact, to Gombrich's suggestion as to Goya's knowledge of Porter's prints.

The Third of May is also part of early nineteenth-century painting's leap into 'contemporary history'. Previously it had been considered inappropriate for painters to depict recent and recognizable events, unless the depiction was formalized and thus to some extent 'distanced' from the viewer. David's painting of *The Tennis Court Oath* (1792) and, for its realism, even more his *Death of Marat* (1793), broke into a quite new idiom and Goya here, under the Restoration, was busy presenting a new picture, the whole style of which would have been inconceivable had it not been

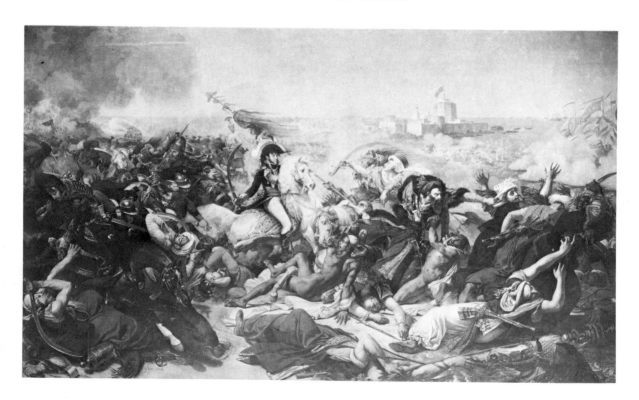

for the Revolution. An old tradition, repeated by both Laurent Matheron and Yriarte, nineteenth-century biographers of Goya, was that David and Goya had met in Rome; and although in fact David did not go to Rome until long after Goya had returned to Spain, such a persistent legend may give a hint at the influence which David may have had. David's most famous pupil, the Baron Gros, painted pictures of the battles of Aboukir [50] and Eylau (1806 and 1808 respectively) which seem to be almost the first pieces of realistic war painting (his famous *Buonaparte visiting the Sick at Acre* is also extremely interesting in this respect). Gros is remarkable in that he was one of the first painters of the first class who actually saw some of the scenes of war which he afterwards depicted, and all these pictures were very well known indeed all over Europe through the prints made of them. One of the dead men in *The Battle of Aboukir* [51] somewhat resembles the fallen figure in *The Third of*

50 *(left)*. Battle of Aboukir, 1806. A.-J. Gros

51 *(right)*. Detail of 50

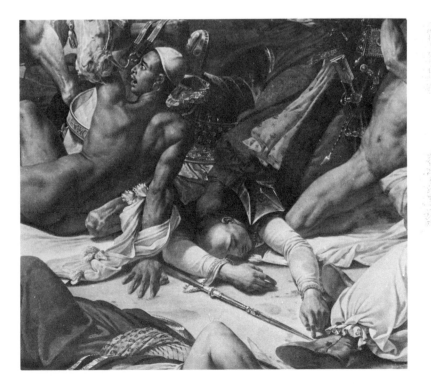

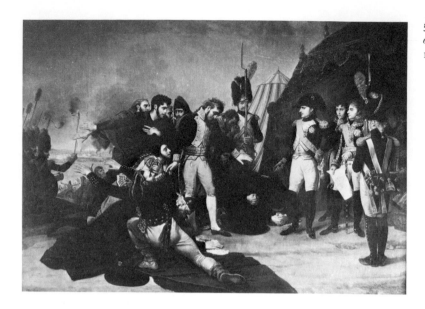

52. *Capitulation
of Madrid, 4 December 1808*,
1810. A.-J. Gros

May.[25] Perhaps Goya, in *The Second* and *The Third of May*, was
trying to present a Spanish answer, suggesting equal heroism, to the
grand battle scenes of his French contemporary. Gros's less satis-
factory *Capitulation of Madrid* [52] may have riled Goya if that
picture was known to him, or at least challenged him.

Another painter of war who saw even more of it in these years was
General Lejeune, aide-de-camp to Berthier, whose battle scenes
included an *Assault on the Monastery of Santa Engracia* [53], the
same engagement depicted by Gálvez and Brambila at Saragossa.
(Lejeune was, incidentally, largely responsible for the introduction
into France of the lithograph, whose inventor, Senefelder, he
encountered in Munich in the campaign of 1800.) Further examples
of this new treatment of history which are contemporary with *The
Third of May* included Géricault's now famous *Officier des Chas-
seurs à Cheval de la Garde Impériale, Chargeant*, exhibited at the
Salon in 1812, though, since Géricault was unknown at the time,
his work could scarcely have been seen by Goya even in the form
of a print.

Afterwards, there were of course very many other examples, headed by the *Massacre of Scio* by Géricault's admirer, Delacroix, who also greatly admired Goya and who must often have seen Goya's portrait of the Directory's ambassador in Spain, Ferdinand Guillemardet, since Guillemardet was Delacroix's godfather and the father of two of his closest friends. (Guillemardet took back with him to France the set of the *Caprichos* which Delacroix copied.) Another painting which echoes Goya's most precisely in historical theme, just following Goya's death, is Antonio Gisbert's *Execution*

53. *Assault on the Monastery of Santa Engracia, Saragossa,* 1809. L.-F. Lejeune

54. *Execution of Torrijos and his companions*, 1837. A. Gisbert

of Torrijos and his companions, in 1831, painted in 1837 [54] and depicting the failure of that famous liberal invasion of Spain which gained the sympathy of Tennyson and his friends at Cambridge. There was also painted in 1871 what might be described as a direct successor to *The Third of May*, namely Vicente Palmeroli's almost pre-Raphaelite *On the Mountain of Príncipe Pío* [55], a picture which is now in the gallery of the Municipality of Madrid.

But *The Third of May* is not only a picture of contemporary history in a new manner. It depicts a scene in which the central figure is not a prince or a cardinal but an ordinary man. The hero is an unknown warrior, the first such in a world previously peopled by recognized men of lineage or saints.[26]

Goya is considered, or used to be, a kind of bridge between the eighteenth-century still 'Italian' style of painting and the universal

style of the nineteenth century; and it is certainly true that from the 1790s onwards Goya, previously a disciple of Tiepolo, was far more interested in achieving his effects by suggestion and impression rather than by a depiction of every detail of what the eye might see after long observation. This is seen quite clearly in *The Third of May*: one has only to imagine how Bayeu or Mengs would have treated that theme to see Goya's innovating spirit. There would have been greater care, much less speed (Goya was usually a very fast painter) and, undoubtedly, less of the truth. (They lived, of course, in a happier time than did Goya.)

In addition, Goya shows himself here something of a symbolist; the lowering presence of the church or monastery in the background clearly expresses authority; the soldiers, oppression and perhaps also Reason; the prisoners, freedom and humanity but also incompetence, failure, and lack of discipline. Malraux, in his curious study of Goya, speaks, a little surprisingly, of 'arid vistas of Arab towns with their catholic belfries revealed in the light of judgement day in *The Third of May 1808*'. But it is not accidental that the

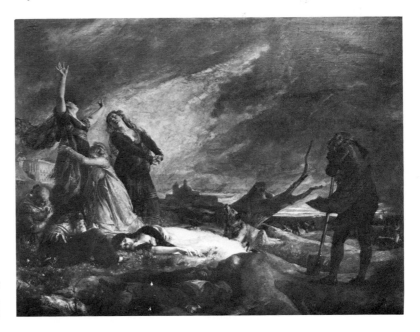

55. *On the Mountain of Príncipe Pío 1808*, 1871. V. Palmeroli

soldiers, with their long rifles, have the lantern. They are the expression of the 'cold Monster', the modern state. The two groups, the Spaniards and the Frenchmen, challenge each other as in a deceiving mirror. Is it far-fetched to imagine, beside this group, one of Goya's looking-glass sketches? A fop looks at a glass and sees a cat; a duchess, a snake; a priest, a frog [56]; and now here is a soldier, who sees a free man – and, alas, vice versa. The soldiers express the efficiency and direction which enabled the French to abolish the Inquisition, break up the monasteries, and plan a new state, but at the same time the brutality which made these things, emanating from that source, unacceptable to so many Spaniards.

56. *Priest and Frog*, 1796–8. Goya

Folke Nordstrom, in the work previously mentioned, has also argued that the different men waiting to be shot represent severally the melancholic, the choleric, and the sanguine man – the monk representing melancholy, the man on his left anger, and sanguinity by the man with his head in his hands.[27]

The background of the picture has a direct relevance to Goya's life; the mound against which the prisoners are being shot, and which seems to have a universal significance, resembles less the

57. Fuendetodos

colour of Madrid than that of the lonely and moonlike hills around Fuendetodos where he spent the first years of his life. The prominent placing of the monasteries or churches in the background, an arrangement found frequently in Goya's paintings, reflects the brooding presence in so many Spanish villages (and none less than Fuendetodos) of a massive church dominating the life of the inhabitants physically as well as psychologically [57].

As suggested earlier, *The Third of May* for many reasons has the air of a lay crucifixion. In composition, it also partakes of one of Goya's own religious paintings – not of a crucifixion, but the *Adoration of the Magi* done by him in the Carthusian monastery of Aula Dei outside Saragossa as early as 1773 [58]: there is the same highly lit central figure, a group of less striking people around him facing a (now partially destroyed) second main figure and, in place of the file of waiting men, two leading sheep from a large flock.

Anticipated by the *Disasters of War*, and anticipating the Black Paintings, *The Third of May* represents Goya's bleakest mood of realism, though with many subtle *doubles entendres* and symbolic suggestions underlying it. It also represents a really decisive mo-

58. *Adoration of the Magi,* 1773. Goya

ment in the unfortunate and ambiguous history of modern Spain. The man in the white shirt does not at all stand for progress himself. On the contrary, his views were doubtless primitive. He may have even been bribed, or filled with alcohol, to take the heroic stand that he did. Or he may have been an innocent passer-by, or a mason at work in the Church of Santiago and San Juan and picked up to be shot, *pour encourager les autres.* If he was a nationalist, as he has always been represented, his was probably a narrow nationalism, reflecting Einstein's view of it that it is 'an infantile disease, the measles of humanity'. He may, in addition, even have been strongly religious and, at this moment, have his mind fixed on God or, since he is a Spaniard, more likely on his local Virgin, even the Virgin of the Pillar at Saragossa, the local deity of his creator, Goya. But, nevertheless, in killing him and his comrades of the riots of 2 May 1808, the French were dealing the hope of Progress a terrible set-back. The future hundred and fifty years – or more – of Spanish political history can be represented as a commentary on the themes suggested in this painting. Here is Patriotism, but it is religious and anti-rational; there is Reason but it is foreign and brutal. The struggle for political enlightenment since those days has been hard. How many thousands or hundreds of thousands of other Spanish patriots have not died, at the hands of their own countrymen in particular, as this man and his comrades die, in vain, honourably and for a cause in which they believed but about which history gives a muffled answer? In the 1970s, would a twentieth-century Goya be able to circulate in Spain a modern version of the *Caprichos* or the *Disasters of War*? Or reproduce Black Paintings on modern themes? Who can be sure of it? If so, who is responsible, the man in the white shirt or the French soldiers? Who can be sure of that either? But probably one of them. Either way, the central figure in this painting represents, alas, the plight of the Spaniard before modern history who, in the words of the great Spanish novelist Pérez Galdos, left his house in 1808 and has not yet found another to which to return.

59. *For being a liberal.* Goya

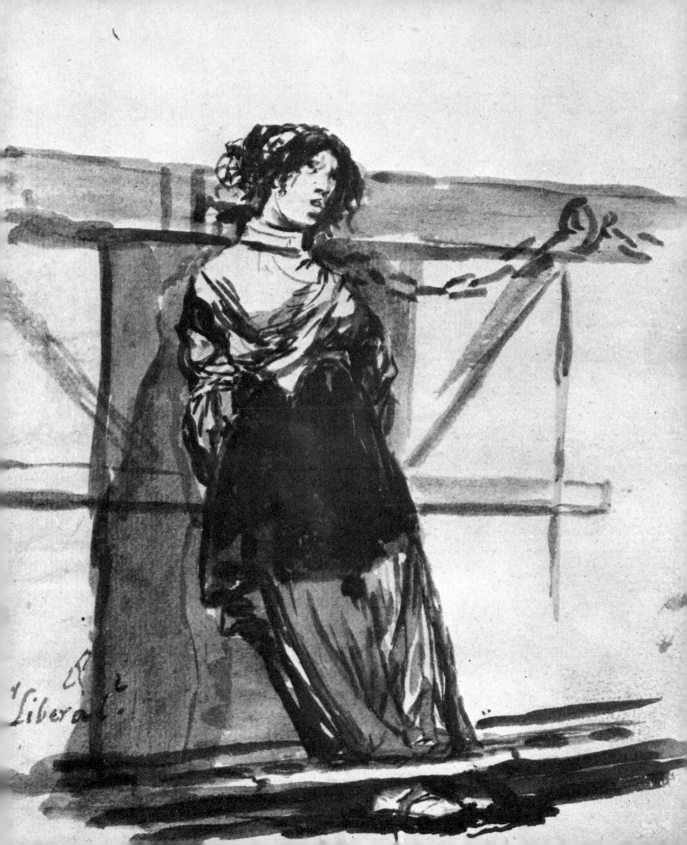

Notes

1. As suggested by José López Rey, *Francisco de Goya*, London, 1951, p. 14.

2. This point was made, apparently for the first time, in Folke Nordstrom, *Goya, Saturn and Melancholy*, Stockholm, 1962, p. 178.

3. op. cit., p. 180.

4. The estate of the Montaña del Príncipe Pío was, in fact, bought by King Charles IV of Spain from the last of the Castell Rodrigo family in 1792 for 1,900,000 reales. The barracks were built in the early 1860s and were always thereafter an important strategic point in Madrid. In the late eighteenth century, the whole quarter was a popular retreat or pleasure place for walking.

5. Orden de S. A. el Regente del Reino, accediendo a que Francisco de Goya perpetuara 'por medio del pincel las más notables y heróicas acciones ó escenas de nuestra gloriosa insurrección contra el tirano de Europa'.

Madrid 9 de marzo, 1814. Fernando VII. Cámara. Leg. no 1

Gobernación de la Peninsula. = En exposición que con fecha de 24 del próximo pasado ha dirigido á la Regencia del Reyno Dn. Francisco Goya pintor de Cámara de S.M., manifiesta sus ardientes deseos de perpetuar por medio del pincel las más notables y heroicas acciones ó escenas de nuestra gloriosa insurrección contra el tirano de Europa, y haciendo presente el estado de absoluta penuria á que se halla reducido y la imposibilidad en que por consiguente se ve de subvenir por sí solo a los gastos de tan interesante obra, solicita que del tesoro público se le suministren algunos auxilios para llevarla a efecto. En su vista y teniendo S.A. en consideración la grande importancia de tan loable empresa y la notoria capacidad del dicho profesor para desempeñarla, ha tenido a bien admitir su propuesta, y mandar en consecuencia que mientras el mencionado Dn. Francisco Goya esté empleado en este trabaxo, se le satisfaga por Tesoraría mayor, además de lo que por sus cuentas resulte invertido en lienzos, aparejos y colores, la cantidad de mil y quinientos reales de vellon mensuales por vía de compensación.

Fho. En 14 de marzo de 1814. Se recibio en 14 del mismo mes.
(*Sambricio, Tapices de Goya*, p. CXLV & CXLVI)

6. Raymond Carr, *Spain 1808–1939*, Oxford, 1966.

7. See list in appendix to J. Pérez de Guzmán: *El Dos de Mayo 1808*, Madrid, 1808.

8. Archivo Municipal de Madrid, quoted by J. Pérez de Guzmán, op. cit., pp. 447–8.

9. H. O'Meara, *Napoleon in Exile*, London, 1822, Vol. II, p. 79.

10. For all these exchanges see Sir Charles Oman, *The Peninsular War*, Oxford, 1901, Vol. I, p. 58.

11. Francisco Bayeu (1734–95), painter of a vast number of frescoes in the new royal palace and elsewhere.

12. Anton Rafael Mengs (1728–79) was Court Painter at Madrid from 1761 to 1779. It is difficult to say what was his nationality, since he was born in Bohemia of a Jewish-Danish father who settled in Dresden.

13. Properly a combination of etching and aquatint. Aquatint consists in coating the copper plate with resin which, when bitten by acid, produces washed tones.

14. José Gudiol, *Goya*, London, 1967, p. 10.

15. P. Gassier and J. Wilson, *Vie et Oeuvre de Francisco Goya*, Fribourg, 1970, p. 34.

16. Alphonse-Louis Grasset, *La Guerre d'Espagne*, Paris 1914, Vol. I, p. 125.

17. A. Malraux, *Saturn. An Essay on Goya*, London, 1957, p. 110.

18. F. J. Sánchez Cantón, *Vida y Obras de Goya*, Madrid, 1951, Notes p. 88.

19. Gassier and Wilson, op. cit., p. 21.

20. This series was apparently first printed in Cádiz in 1814. Juan Gálvez (1774–1847) executed frescoes in the staircase of the Prado.

21. The figure of Madrid is depicted resting her right hand against a shield bearing the arms of the city and pointing with her left hand to a medallion which originally contained Goya's portrait of Joseph Bonaparte and now bears the legend 'Dos de Mayo'. On 23 December 1809 the Town Council of Madrid decided to have made 'by the best painter' a portrait of 'our Sovereign' (Joseph Bonaparte). Tadeo Bravo de Ribera was delegated to find a painter and on 27 February 1810, advised the council that he had entrusted the work to Goya who had already composed the painting, using for the head of Joseph (then absent from Madrid) an engraving made in Rome. After the liberation of Madrid from the French in August 1812, the portrait was over-painted and substituted with the word *Constitución* (the Government that took over power), but

101

was replaced by another portrait of Joseph when the French returned later in the year. In 1813 this was again over-painted and the word *Constitución* substituted which was, in its turn, substituted with a portrait of Ferdinand VII when the king returned to the throne in 1814. This was replaced by a better portrait in 1823. In 1842 this was replaced once again by words, this time *El Libro de la Constitución*, only to be followed shortly afterwards by the decision to recover the original portrait of Joseph Bonaparte. But Vicente Palmeroli only found vestiges of Goya's portrait remaining and painted the legend DOS DE MAYO in its place. See F. Pérez y González, *Un cuadro . . . de historia. Alegoría de la Villa de Madrid*, Madrid, 1910, and Valentín de Sambricio, Catálogo. *Esposición Goya, IV Centenario de la Capitalidad*, Madrid, 1961, no. 1.

22. For sources on the commission see note 5 above.

23. T. Gautier, *Voyage en Espagne*, Paris, 1870, p. 117.

24. 'Images and Art in the Romantic Period' in E. H. Gombrich, *Meditations on a Hobby Horse*, London, 1963, p. 125. R. K. Porter (1777-1842) was afterwards knighted on his return from Russia. Despite what Gombrich says, there is no evidence that Porter went to Saragossa and indeed it would be most improbable if he did. It is therefore most unlikely that he and Goya met. Porter's sister, Jane, was the author of the enormously successful historical novel *The Scottish Chiefs*, published in 1810.

25. The pose can, of course, be found in works by earlier artists, e.g. for Saul in Antonio Tempesta's engraving of *The Death of Saul*, or for an unidentified figure in Charles le Brun's painting of the *Battle of Alexander and Darius*, in the Louvre.

26. There had, however, been a seventeenth-century vogue for battle pieces which were simply scenes of carnage without any apparent historical or literary programme and without any hero, see F. Saxl: 'The Battle Scene without a Hero' in *Journal of the Warburg Institute*, III (1940) pp. 70-87, in which it is shown that the battle pieces by the early seventeenth-century Neapolitan painter, Aniello Falcone, had no political overtones whatever.

27. op. cit., p. 184.

Bibliographical Note

The most complete life of Goya is that in the magnificent volume of Pierre Gassier and Juliet Wilson, *Vie et Oeuvre de Francisco Goya*, Office du Livre, Fribourg, 1970. This largely but not entirely supersedes F. J. Sánchez Cantón's scholarly *Vida y Obras de Goya*, Madrid, 1951. Other general studies include: F. D. Klingender, *Goya in the Democratic Tradition*, London, 1948, a stimulating attempt at a social history; and Antonia Vallentin, *This I Saw*, London, 1949, suggestive if impressionistic. A stimulating general study is Folke Nordstrom's *Goya, Saturn and Melancholy*, Stockholm, 1962.

Among special studies, there are: Valentín de Sambricio, *Tapices de Goya*, Madrid, 1946, which illuminates much more than the tapestries; F. J. Sánchez Cantón, *Goya et ses peintures noires à la Quinta del Sordo*, Milan-Paris, 1963, of which the same can be said in respect of the Black Paintings; Edith Helman, *Trasmundo de Goya*, Madrid, 1963, a stimulating study of the background to the *Caprichos*; and there is Enrique Lafuente Ferrari, *Goya, The Frescoes in San Antonio de la Florida*, New York, 1955. Lafuente Ferrari has also a little book on *The Second* and *Third of May* (*Goya, El dos de Mayo y los Fusilamientos*, Barcelona, 1946). There is also Richard Tügel's *Francisco de Goya, Der Erschiessung von der Dritte Mai, 1808*, Stuttgart, 1960, which adds little.

On the historical side of this account, there are: Raymond Carr, *Spain 1808-1939*, O.U.P., 1965; Richard Herr, *The Eighteenth Century Revolution in Spain*, Princeton, 1958; J. Pérez de Guzmán, *El Dos de Mayo 1808*, Madrid, 1908; Geoffroi de Grandmaison, *L'Espagne et Napoléon 1804-1808*, Paris, 1908; Sir Charles Oman, *The Peninsular War*, particularly Vol. I, Oxford, 1901, though it is very anti-*afrancesado*; and Manuel Izquierdo Hernández, *Antecedentes y Comienzos del Reinado de Fernando VII*, Madrid, 1963.

On Manet and Goya, see N. G. Sandblad, *Manet, Three Studies in Artistic Conception*, Chapter III (*L'exécution de Maximilien*), Publications of the New Society of Letters at Lund, Lund, Sweden, 1954.

Among interesting articles relating to the subjects discussed here are: Georges Demerson, *Goya, en 1808, no vivía en la Puerta del Sol*, Archivo Español de Arte, Vol. XXX, No. 119. (July-September 1957); José López

Rey, *Goya and the World around him, Gazette des Beaux Arts*, 6th series, Vol. XXVIII, 1945, New York, p. 129; and F. J. Sánchez Cantón, *Cómo vivía Goya, Archivo Español de Arte*, XIX, 1946 (an inventory of Goya's possessions in 1812).

List of Illustrations

(c) Frontispiece to *Los Caprichos*. By Goya, *c.* 1799. (Photo: Mas.)

(d) *Self portrait*. By Goya, 1814. Madrid, Real Academia de Bellas Artes de San Fernando. (Photo: Mas.)

23. *The Family of the Duke of Osuna*, detail. By Goya, *c.* 1789. Madrid, Prado. (Photo: Mas.)

24. *The Duchess of Alba*, detail. By Goya, 1795. Madrid, collection: Duke of Alba. (Photo: Mas.)

25. Sketch for *Back to his Grandfather (Asta su abuelo)*, No. 39 Los *Caprichos*. By Goya, *c.* 1799. Madrid, Prado. (Photo: Mas.)

26. *Attack on the Diligence*, No. 8 *Les misères de la guerre*. By Jacques Callot, published 1636. London, British Museum Print Room. (Photo: Museum.)

27. *Attack on the Diligence*. By Goya, *c.* 1792–1800. Madrid, collection: Marqués de Castro Serna. (Photo: Mas.)

28. *I saw it (Yo lo vi)*, No. 44 *Disasters of War (Los Desastres de la Guerra)*. By Goya, *c.* 1810. Barcelona, collection: Torelló. (Photo: Mas.)

29. Detail of map of Madrid, *c.* 1780; adapted from a map by Tomás López presented to Floridablanca in 1783.

30. *Josefa Bayeu*. By Goya, 1805. Madrid, collection: Casa Torres. (Photo: Mas.)

31. *For this you were born (Para eso habeis nacido)*, No. 12 *Disasters of War*. By Goya, *c.* 1810. Barcelona, collection: Torelló. (Photo: Mas.)

32. *Josef de la Hera*, from *Ruins of Saragossa (Ruinas de Zaragoza)*, published Cádiz, 1814. By Juan Gálvez and Fernando Brambila. London, British Museum Print Room. (Photo: Museum.)

33. *Ruinas del Patio del Hospital General de N.S. de Gracia*, from *Ruins of Saragossa*, published Cádiz, 1814. By Juan Gálvez and Fernando Brambila. London, British Museum Print Room. (Photo: Museum.)

34. *A Nightmare*, from *Sueños de una noche*. By Goya, *c.* 1799–1808. Madrid, Prado. (Photo: Mas.)

35. *That's tough! (Fuerte cosa es!)* detail, No. 31 *Disasters of War*. By Goya, *c.* 1810. Barcelona, collection: Torelló. (Photo: Mas.)

36. *Populacho*, No. 28 *Disasters of War*. By Goya, *c.* 1810. Barcelona, collection: Torelló. (Photo: Mas.)

37. *Disparate Conocido*, No. 19 *Disparates*. By Goya, *c.* 1815–24. Paris, collection: Le Garec. (Photo: Mas.)

38. *Execution of the Emperor Maximilian of Mexico*. By E. Manet, 1867. Mannheim, Kunsthalle. (Photo: Museum.)

39. *La Tauromaquia*, No. 13. By Goya, *c*. 1816. Barcelona, collection: Torelló. (Photo: Mas.)

40. *With reason or without it (Con razón o sin ella)*, No. 2 *Disasters of War*. By Goya, *c*. 1810. Barcelona, collection: Torelló. (Photo: Mas.)

41. *And there is no remedy (Y no hay remedio)*, No. 15 *Disasters of War*. By Goya, *c*. 1810. Paris, Bibliothèque National. (Photo: Bulloz.)

42. *One cannot bear to see this (No se puede mirar)*, No. 26 *Disasters of War*. By Goya, *c*. 1810. Madrid, Prado. (Photo: John Webb.)

43. Sketch for *Even worse (Tanto y más)*, No. 22 *Disasters of War*. By Goya, 1810. Madrid, Prado. (Photo: Mas.)

44. *An Execution*. By Goya, 1810. Madrid, collection: Marquesa de la Romana. (Photo: Mas.)

45. *The Third of May 1808*. Drawing attributed to Goya, 1814. London, collection: Pierre Jeannerat.

46. *The Third of May 1808*. Sketch attributed to Goya, 1814. New York Hispanic Society. (Photo: Museum.)

47. *An Execution*, No. 12 *Les misères de la guerre*. By Jacques Callot, published 1636. London, British Museum Print Room. (Photo: Freeman.)

48A. *Buonaparte massacring 3,800 men at Jaffa*. Print after R. K. Porter, 1803. London, British Museum Print Room. (Photo: Freeman.)

48B. *Buonaparte massacring 1,500 persons at Toulon*. Print after R. K. Porter, 1803. London, British Museum Print Room (Photo: Museum.)

49. *Battle of Aspern-Esling*. Lithograph after H. Jannin, 1809. London, collection: Hugh Thomas. (Photo: Freeman.)

50. *Bataille d'Aboukir*. By A.-J. Gros, 1806. Versailles. (Photo: Bulloz.)

51. Detail of 50.

52. *Capitulation of Madrid, 4 December 1808*. By A.-J. Gros, 1810. Versailles. (Photo: Bulloz.)

53. *Assault on the Monastery of Santa Engracia, Saragossa*. By L.-F. Lejeune, 1809. Versailles, Musée de l'Histoire de France. (Photo: Museum.)

54. *Execution of Torrijos and his companions*. By A. Gisbert, 1837. Madrid, Museo de Arte Moderna. (Photo: Mas.)

55. *On the Mountain of Príncipe Pío 1808*. By V. Palmeroli, 1871. Madrid, Ayuntamiento. (Photo: Mas.)

56. *Priest and Frog*. By Goya, 1797-8. Madrid, Prado. (Photo: Mas.)

57. Fuendetodos. General view of the church. (Photo: Mas.)

58. *Adoration of the Magi.* Bv Goya, 1773. Saragossa, Cartuja de Aula Dei. (Photo: Mas.)

59. *Por Liberal.* By Goya. Madrid, Prado. (Photo: Mas.)

Index